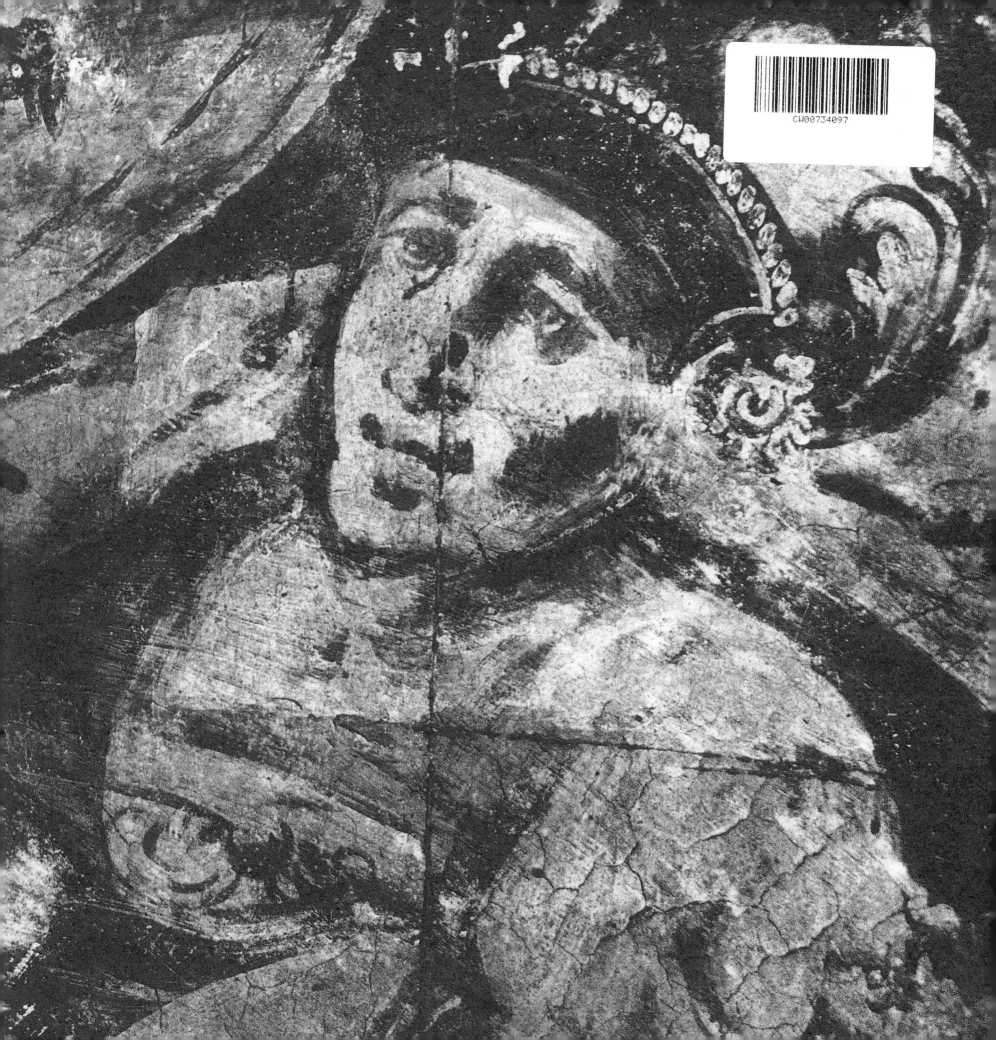

For James with best
Regards

Duncan –

Beyond the Wall

A divided land, one again,
but the Scars remain.

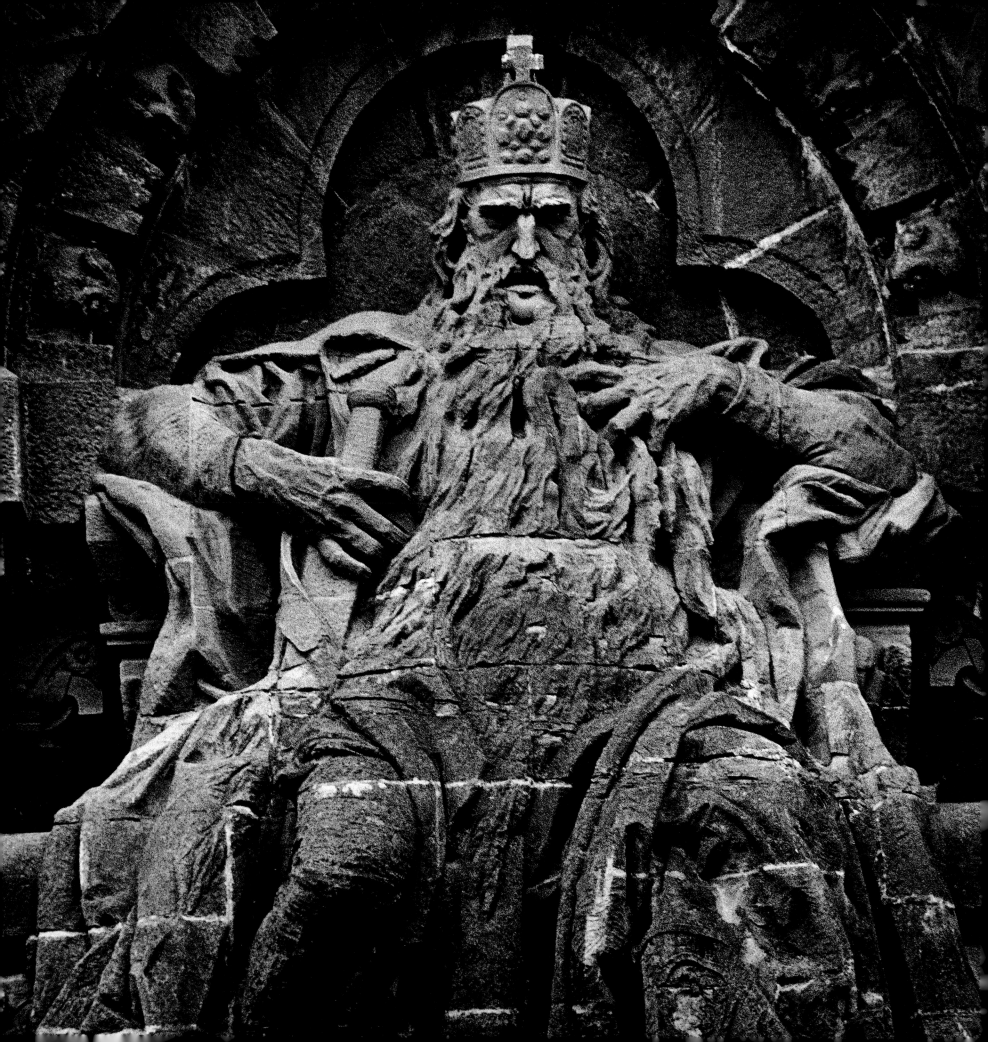

Beyond the Wall

THE LOST WORLD OF EAST GERMANY

Simon Marsden &

Duncan McLaren

Little, Brown and Company
BOSTON NEW YORK LONDON

A LITTLE, BROWN BOOK

First published in 1999
by Little, Brown and Company (UK)

Text copyright © 1999 by Simon Marsden and Duncan McLaren
Weissbuch ueber die 'Demokratische Bodenreform' in der Sowjetischen Besatzungszone Deutschlands: Dokumente und Berichte
First edition copyright © 1955 by Arbeitsgemeinschaft Deutscher Landwirte und Bauern e.V.
Second edition copyright © 1988 by Joachim von Kruse, Verlag Ernst Voegel, Munich, Stamsried
Photographs copyright © 1999 by Simon Marsden

The moral right of the authors has been asserted.

A CIP catalogue record for this book is available from the British Library

ISBN 0-316-64538-9

Designed by Andrew Barron and Collis Clements Associates
Printed and bound in Italy

Little, Brown and Company (UK)
Brettenham House, Lancaster Place
London WC2E 7EN

Dedication

For Lt Sir John Marsden (1913–1985), captured in May 1941 during the invasion of Crete, held prisoner in Oflag VII B in Eichstätt, Bavaria until 1945.

For Sq Ldr Robert D. McLaren DFC (1917–1945). Awarded for his part in the sinking of SMS *Turpitz* 1944. Killed in action.

For Capt T. A. Staunton (b. 1915), Queen's Own Rifles of Canada, D-Day Landing, Juno Beach.

Endpapers:
Detail from the wall paintings on the Reithalle (Riding Hall), Schloss Heidecksburg, Rudolstadt

Half-title page:
A statue at Sanssouci Park, Potsdam

Title page:
The monument to Emperor Frederick Barbarossa, Kyffhäuser Mountain

Contents page:
Satyrs at the Zwinger Palace, Dresden

Contents

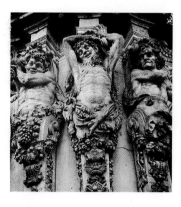

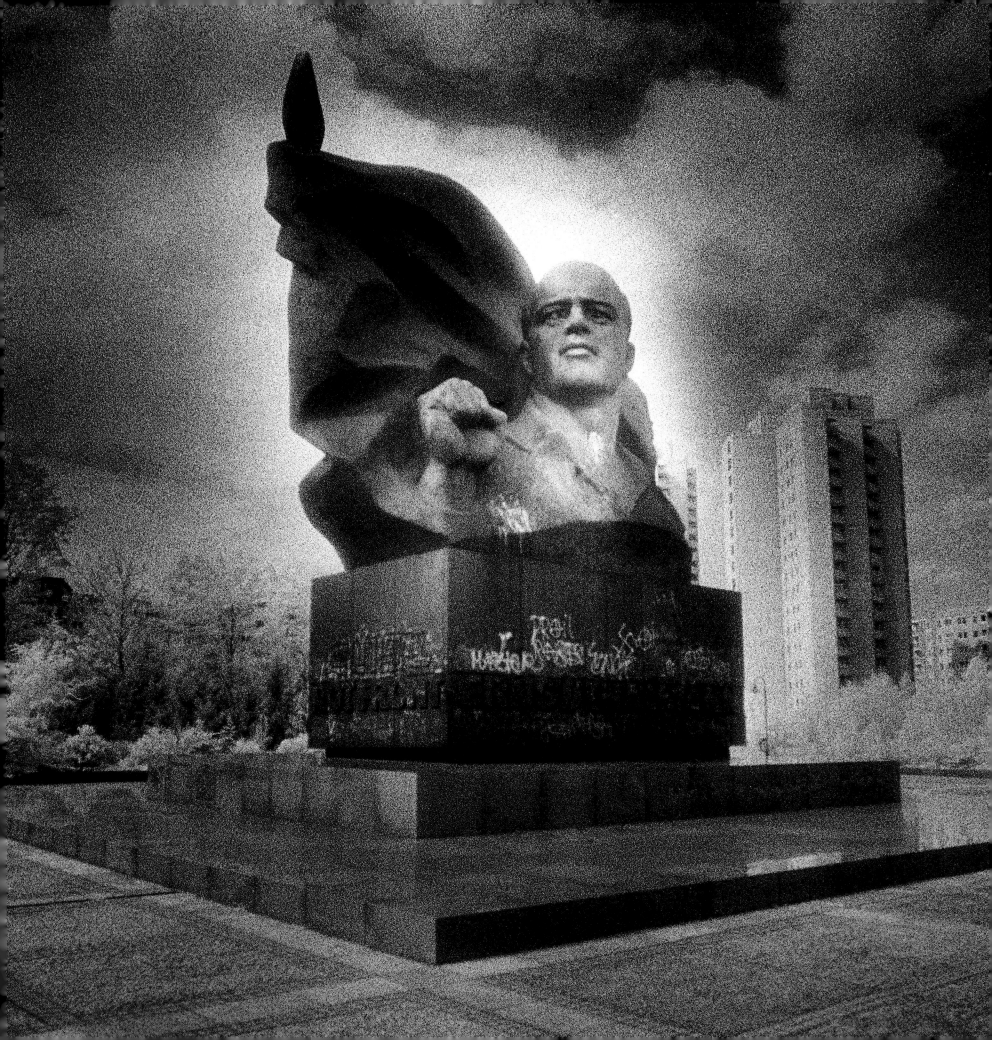

‘ It is with a sense of awe that they [the Germans] turned upon Russia the most grisly of all weapons. They transported Lenin in a sealed truck like a plague bacteria from Switzerland into Russia. ’

Winston Churchill

‘ The broad mass of a nation … will more easily fall victim to a big lie than to a small one. ’

Adolf Hitler
Mein Kampf

‘ Civilization has made the peasantry its pack animal. The bourgeoisie in the long run only changed the form of the pack. ’

Leon Trotsky
History of the Russian Revolution

‘ All that remains of these cities will be the wind that blew through them. ’

Bertold Brecht
Vom armen B.B.

‘ One death is a tragedy, a million deaths a statistic. ’

Attributed to Joseph Stalin

‘ I cannot forecast to you the action of Russia. It is a riddle wrapped in a mystery inside an enigma. ’

Winston Churchill

‘ An iron curtain would at once descend on this territory which, including the Soviet Union, would be of gigantic size. ’

Joseph Goebbels
In 1945, on the consequences if Germany were to surrender

‘ In Russia, a man is called a reactionary if he objects to having his property stolen and his wife and children murdered. ’

Winston Churchill

Opposite:
A statue of Ernst Thälmann, East Berlin

Overleaf:
A section of the Berlin Wall

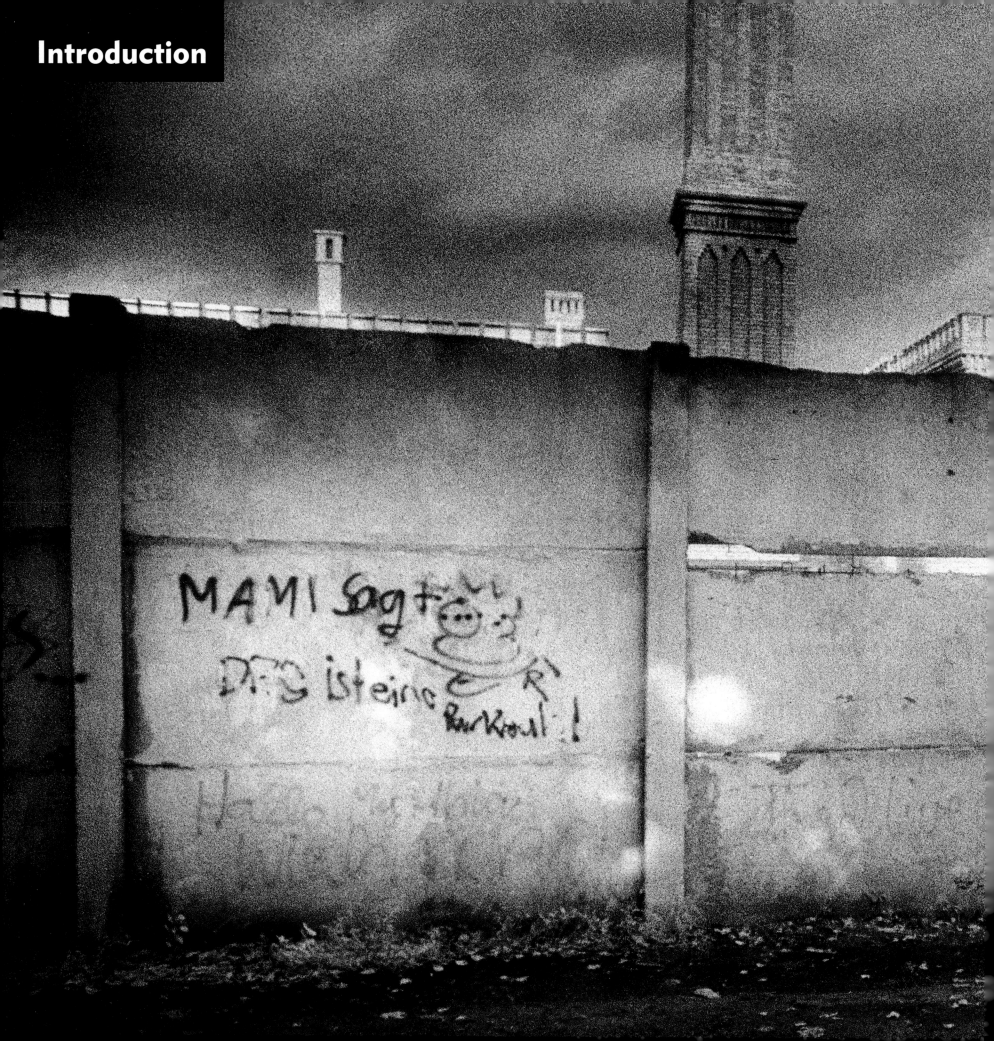

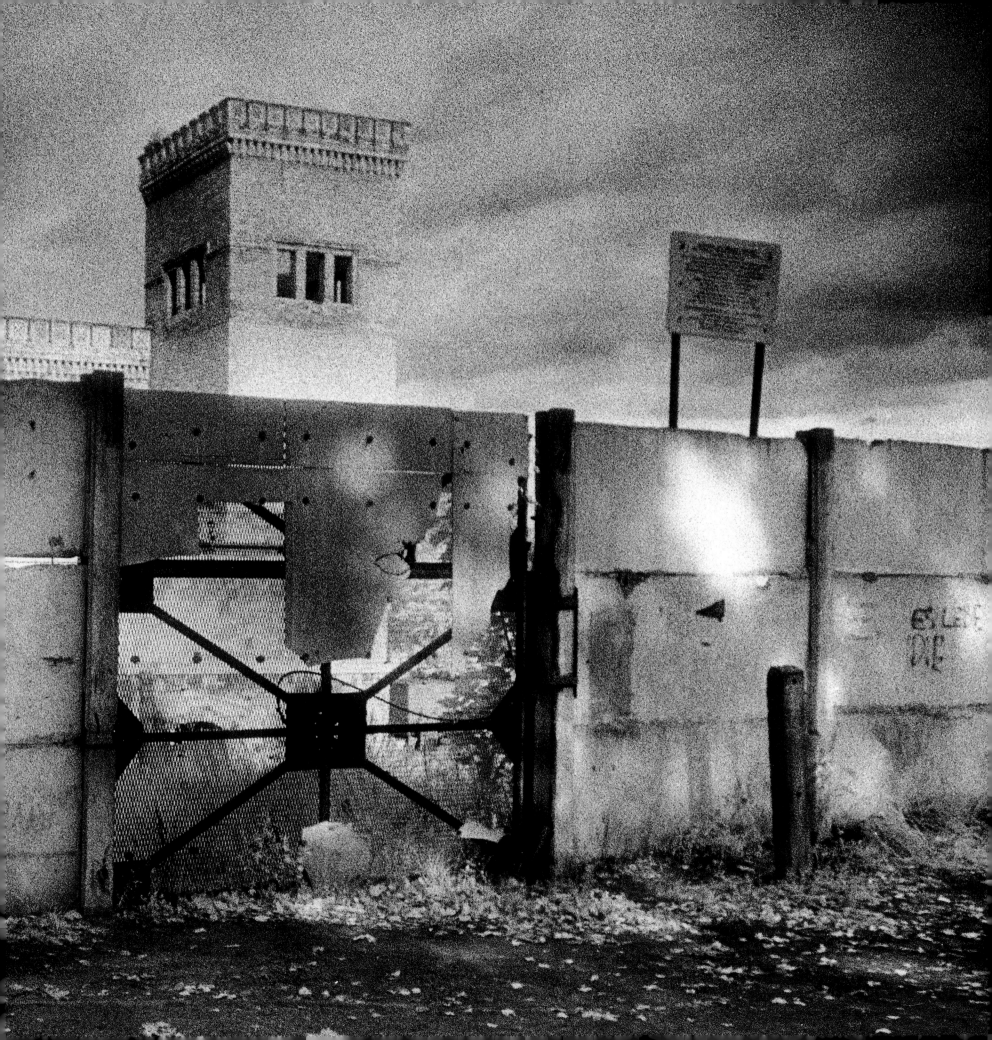

Introduction

There is silence here in the countryside of Oxfordshire in August. The sun is bright; the grass is brown. There is a haze, the timeless haze of summer. I am home.

I expect there is not much difference between this day and another in the summer of 1945, in the states of what were to become the German Democratic Republic: Mecklenburg-Vorpommern, Sachsen-Anhalt, Thüringen, Sachsen and Brandenburg. When the war was over, families returned to their houses, castles, cottages and villas. Perhaps as with the last war there would be time to recover, to restore, to clean and repair the horrors of the last five years; to mourn the dead, and see the family; to rebuild the fallen towns and cities lying in rubble in so many places.

But it was not to be. These states fell into the newly created Russian sector, and people knew that the treatment would be hard, as hard as that inflicted on the Russians by the Germans. But no one quite conceived to what extent.

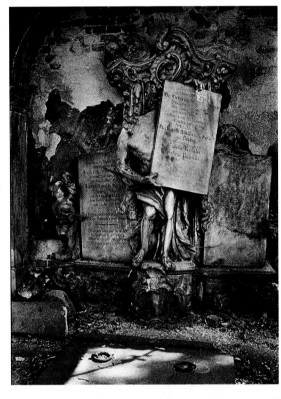

What would you take if you were given one hour to leave your home? That is a question that we in Western Europe did not have to answer, but those under the Soviets in East Germany did. Even when the Yalta Agreement between the powers of America, Britain and the USSR had, with the signatures of Roosevelt, Churchill and Stalin, agreed to world freedom of the individual, the Rights of Man and all things that go with great signings. The East Germans had to decide what to take and flee; and flee they did. Many were murdered, raped or committed suicide and many others were sent to the concentration camps. Millions of people were on the move.

How simple it must have seemed to the Soviet military who took charge over the local but Soviet-trained German Communist Party. An unprecedented attack on the civilian population to eliminate the people who owned the land, property, factories and industries was under way. Documents for their annihilation were

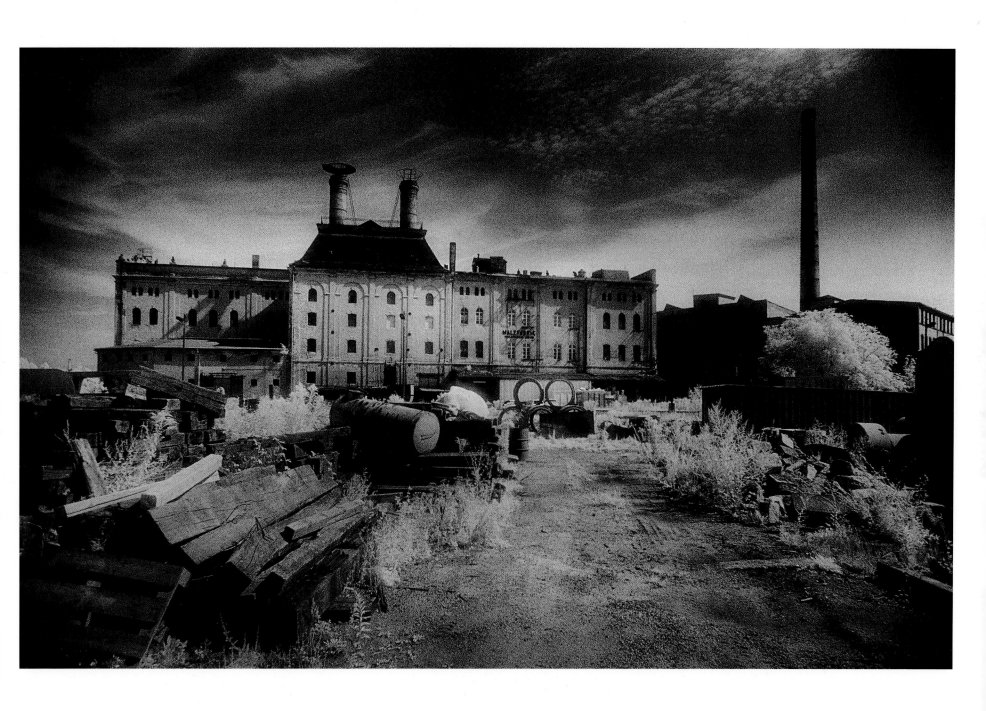

Opposite:
Detail from a mausoleum in
Zittau, Sachsen

Above:
An abandoned factory in
Löbau, Sachsen

being prepared even during Yalta. There would be no compensation. The Agrarian Reform meant total confiscation of all private property and land of over 100 hectares, all building machinery, livestock, dead stock, motor vehicles, bank funds, shares, furs, silver, furniture – everything people owned, except what they stood up in or could put into an overnight bag, excluding valuables. By January 1949 7,200 estates over 100 hectares were expropriated, totalling 2,504 million hectares.

Out – off – go, and so by the orders of Communist officials in the region by letter or visit they were told to leave their land, and given instructions to walk in this direction or that. They were driven away from the place they called home and their livelihood was taken away.

In six months, the Soviet occupation of East Germany destroyed 800 years of feudal enterprise and for fifty years wrecked a production system of agriculture, food and industry that supplied the cities and people of the German states, and was the envy of Europe – before the war agricultural production was the highest in Europe. The cancer of Communism devastated the top, middle and bottom of the economic scale in the name of equality. For the whole spectrum of people – landowners, farmers, industrialists, shop and innkeepers, lawyers, tradesmen, aristocrats, princes and factory workers – the story was the same: fifty years of economic oblivion. The landed families had been dispossessed and their estates turned into wasteland, asylums and ruins. Towns and cities that had suffered the ravages of the Second World War were left as open wounds to decay and, as a final insult, hideous factories were built amidst the beautiful landscape by the Communist regime. What a ghastly world of hatred Stalin created for the losers of Hitler's awful aggression.

Our journey through East Germany was extraordinary, and started in the 1990s after the Berlin Wall came down. Time moves quickly when you are given the opportunity to revitalise, and the last years of this decade have indeed seen a great period of reconstruction. Scaffolders, masons, carpenters,

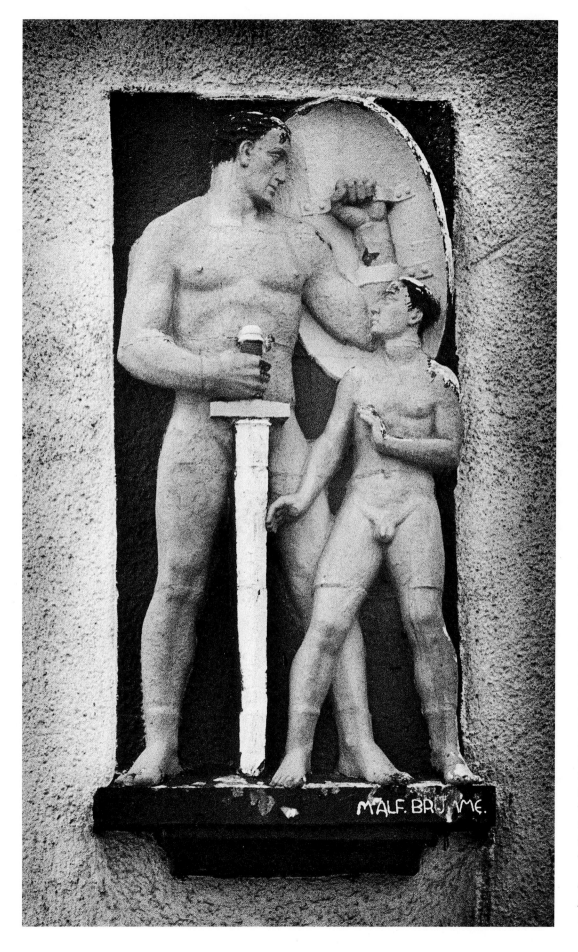

electricians, bankers, lawyers, aggrieved past and present owners – all have played their part in bringing East Germany back from the horrors of Communist rule. But for the original owners it is impossible; they cannot restore the past. Their houses might be returned to them, but without land, contents and neighbours or the infrastructure that had been built up over the years. They do not have the money to restore the avenues, gardens and factories of yesteryear.

The wonder, for Simon and me, was to see, and for him to capture, this time before the great houses become château hotels or people's palaces, or fall into complete decay. We toured through the troubled states, the houses, castles and palaces, and photographed their sculpture, tombs, interiors and churches. We collected stories from those who had suffered – from books, from friends and from families who no longer live there. Where we were unable to gain first-hand accounts, we have included extracts from the *Weissbuch*, which was

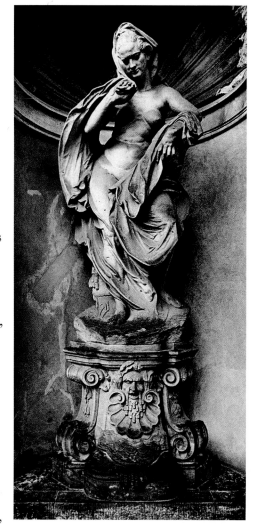

published in 1955. This is a collection of harrowing statements from owners who had been forced to flee their ancestral estates during desperate times. Such moving accounts have been combined with our own observations and experiences from our journey.

Now that the two Germanys are once again united, the vast programme of restoration and modernisation is well advanced in the East. This photographic essay therefore captures a unique moment in our century that has largely been ignored and will soon vanish forever.

It is now ten years since those momentous events in October 1989. The healing has begun; order is returning. Berlin will again be the capital – the cranes and stevedores are working around the clock. History cannot be eradicated from our memories, nor should it be. Before we forget how horrific the middle of this century was for so many people, here is a reminder of things past. DHMcL

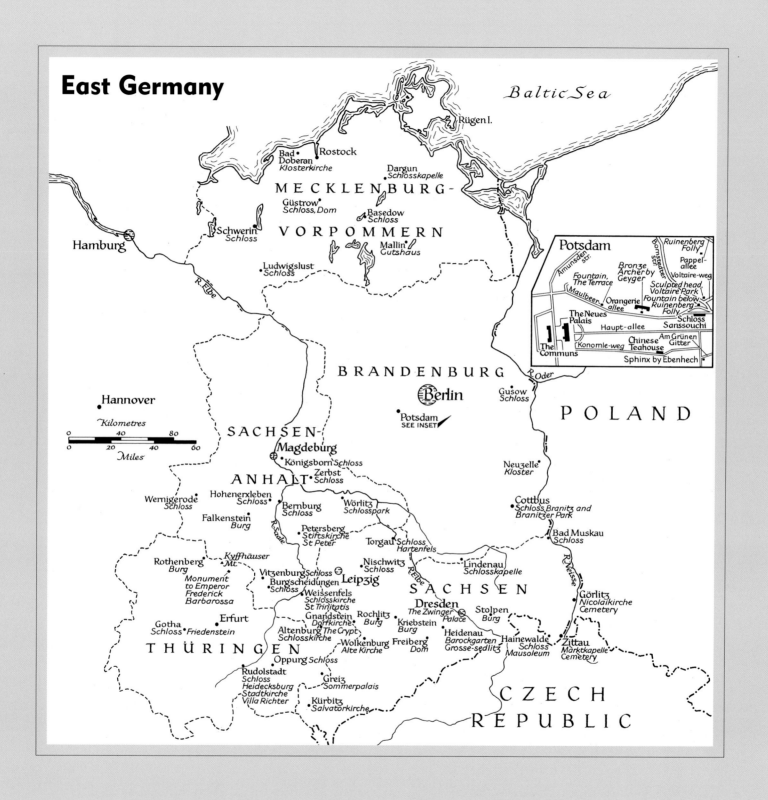

East Germany

Baltic Sea

Rügen I.

Rostock
Bad
Doberan
Klosterkirche

Dargun
Schlosskapelle

MECKLENBURG-

Güstrow
Schloss, Dom

Basedow
Schloss

VORPOMMERN

Schwerin
Schloss

Mallin
Gutshaus

Hamburg

Ludwigslust
Schloss

R. Elbe

BRANDENBURG

Berlin

Gusow
Schloss

R. Oder

Hannover

Potsdam
SEE INSET

Kilometres
0 40 80
0 20 40 60
Miles

SACHSEN-
Magdeburg
Königsborn *Schloss*

Neuzelle
Kloster

POLAND

ANHALT
Zerbst
Schloss

Wernigerode
Schloss

Hohenerxleben
Schloss

Bernburg
Schloss

Wörlitz
Schlosspark

Cottbus
*Schloss Branitz and
Branitzer Park*

Falkenstein
Burg

R. Saale

Petersberg
*Stiftskirche
St Peter*

Torgau *Schloss
Hartenfels*

Bad Muskau
Schloss

Kyffhäuser
Mt.

Rothenberg
Burg

Vitzenburg *Schloss*

Burgscheidungen
Schloss

Leipzig

Nischwitz
Schloss

Lindenau
Schlosskapelle

R. Neisse

Monument
to Emperor
Frederick
Barbarossa

Weissenfels
*Schlosskirche
St Trinitatis*

SACHSEN

Görlitz
*Nicolaikirche
Cemetery*

Gnandstein
Dorfkirche

Rochlitz
Burg

Dresden
*The Zwinger
Palace*

Stolpen
Burg

Gotha
Schloss *Friedenstein*

Erfurt

Altenburg *The Crypt
Schlosskirche*

Kriebstein
Burg

Freiberg
Dom

Heidenau
*Barockgarten
Grosse-sedlitz*

Hainewalde
*Schloss
Mausoleum*

Zittau
*Märktkapelle
Cemetery*

Oppurg *Schloss*

Wolkenburg
Alte Kirche

THÜRINGEN

Rudolstadt
*Schloss
Heidecksburg
-Stadtkirche
Villa Richter*

Greiz
Sommerpalais

CZECH

Kürbitz
Salvatorkirche

REPUBLIC

Potsdam

Amunsden str.

Bornstedter str.

Ruinenberg
Folly

Pappel-
allee

Bronze
Archer by
Geyger

Voltaire-weg

Fountain,
The Terrace

Sculpted head
Voltaire Park

Fountain below
Ruinenberg
Folly

Maulbeer-
allee

Orangerie
allee

The Neues
Palais

Haupt-allee

Schloss
Sanssouchi

Am Grünen
Gitter

The
Communs

Konomie-weg

Chinese
Teahouse

Sphinx by Ebenhech

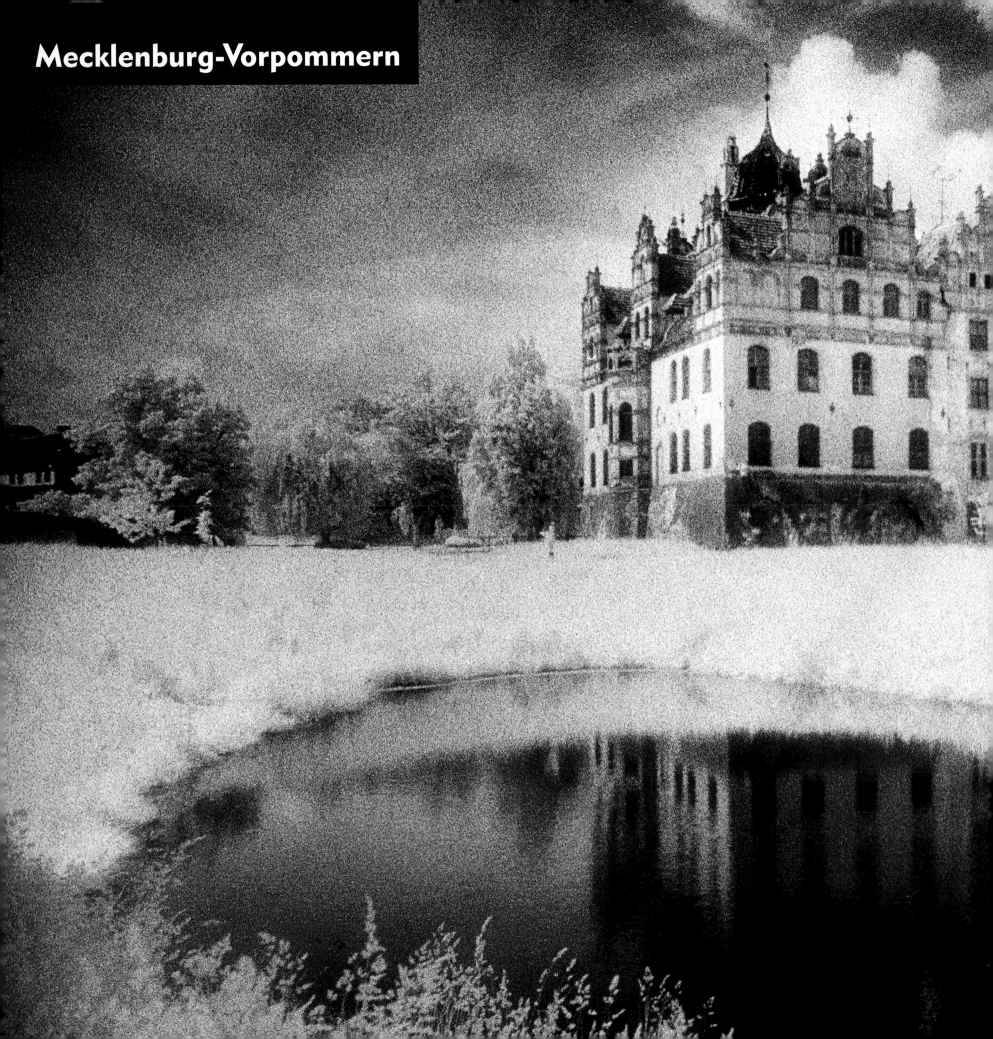

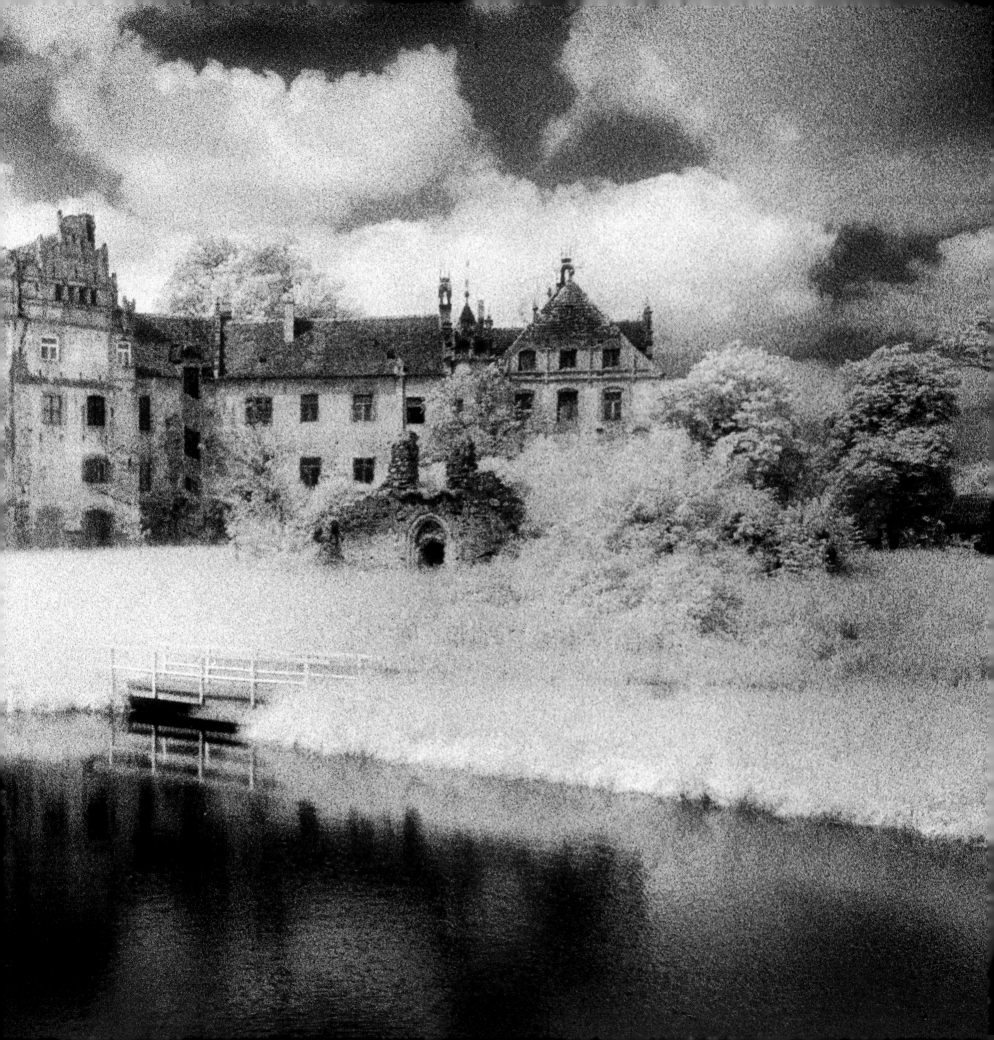

Gutshaus Mallin

In the dark, overgrown pond below the house I could see an old, rusting child's pram, the face of a grandfather clock and a broken jewel casket.

Inside the mansion a white owl perched on the remains of a massive glass chandelier. Beneath it, scattered across the floor, were numerous torn and faded manuals of Communist literature, damp and disintegrating, like the building itself.

Nobody in the small village could tell us anything about the house's history, except that it had been built towards the end of the nineteenth century. It seemed as if everything had been lost in time.

Simon Marsden

Previous page:
Schloss Basedow

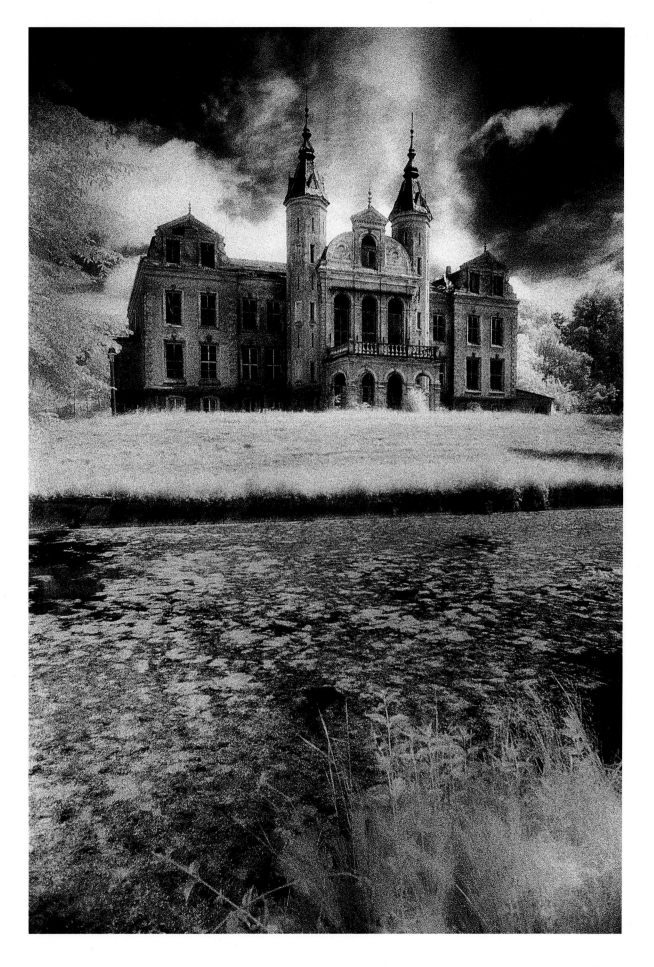

Schloss Ludwigslust

On 2 May 1945, the Russians suddenly appeared, jumped from their horses and forced their way into the house at gunpoint. They took everything they could find and raped the girls. My husband was beaten, because he couldn't carry the tyres, which

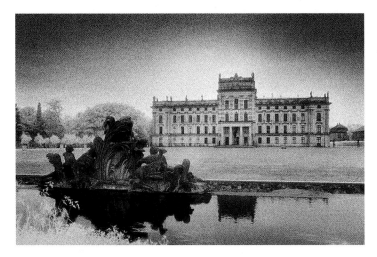

he had to hand over. Then they discovered an old camera case, declared it was a bomb and wanted to shoot my husband. A Polish woman, who had worked for us, shouted: 'Good man, don't shoot'. With these words she saved his life. The raids happened nearly every day, often during the night. The house was looted completely, often with the assistance of the Communists from T. All the livestock were herded away. Our neighbour, Dr W., was shot on 2 May by a Pole.

We were informed of the impending expropriation in a telephone call from a German officer in T. We were extradited on 10 November 1945.

***Weissbuch* Nr 51 (Countess B.-W.)**

Left:
The Baroque schloss at Ludwigslust was built between 1772 and 1776 for the Dukes of Mecklenburg. The once sumptuous interiors have deteriorated after long years in service as municipal offices under the Communists. Much of the mansion's treasure was plundered, but the resplendent Goldener Saal, or Banqueting Hall, has been preserved amidst the drabness and decay.

Opposite:
The waterfall in front of the schloss. The two river gods on either side of the Mecklenburg coat of arms were created by the Bohemian sculptor Rudolph Kaplunger.

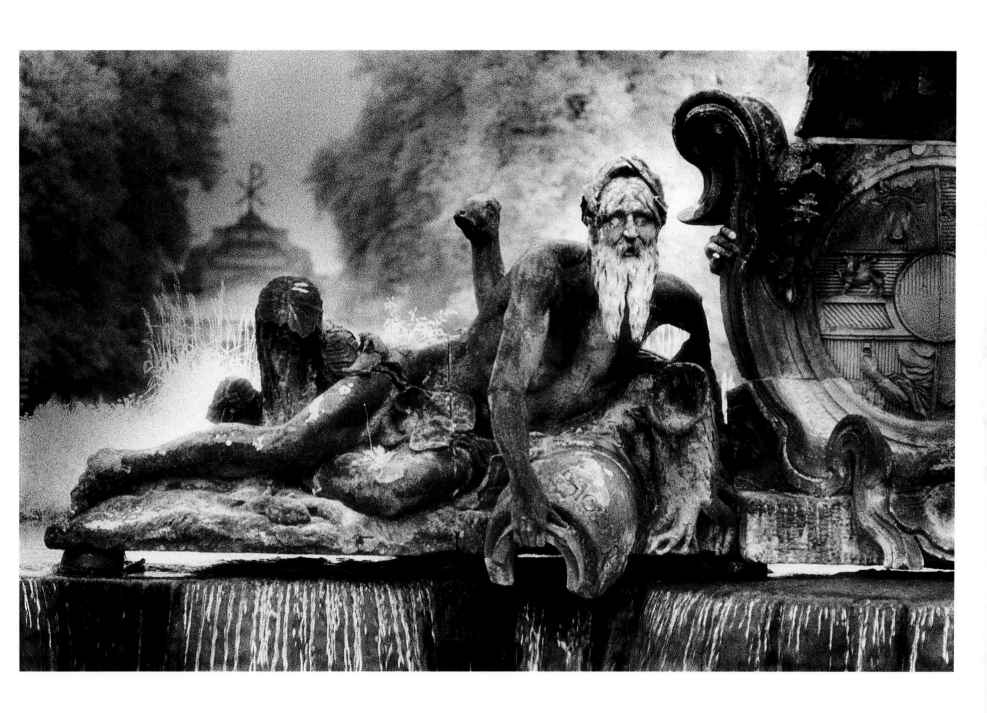

Schloss Güstrow

Vicious knocking disrupts our restless sleep. We can hear shouting: 'Treckbefehl! Order to leave.' It is the night of 8 March 1945, and it is still completely dark. While I get dressed hastily, Frieda collects my suitcases.

Soon we all meet up. The luggage towers in the hall, which resembles a train station. Then breakfast is served. 'Eat!' commands father Jesko [her stepfather]. 'There won't be lunch.' But nobody is able to eat a thing; only the coffee has any appeal. Nobody finds the heart to make conversation.

Meanwhile, Maria hauls out her provisions: a laundry basket full of sandwiches and thermos bottles, a second one with bread, a third with ham, sausages, jam jars, and on and on it goes. Father looks at her accusingly. He picks up a jam jar, twists it open and shakes the pickles on to the floor, on to the carpet. A wave, a finger points at Faust, the hunting dog, who starts to eat with joy.

This silent scene makes my heart bleed, and I'm sure that I'm not the only one who feels ill at ease. The carpet is one of the most treasured pieces in the house. 'Don't you dare!' we were told, if we so much as thought of stepping on it with anything but spotlessly clean shoes – and I doubt that anyone has ever dared to. But now it is degraded to a feeding place for a dog. No words could have described our present situation to us more clearly: it's gone, gone forever. The main doors are open. Sounds can be heard from outside – wheels and horses. The carriages arrive. It will take a couple of minutes for the luggage to be stowed away. I go to my room, close the door, and lean close to the wall for one last breath, one last look.

The door creeps open. Two women come in, very quiet, on tiptoes; they are two of the bomb refugees, who were taken in by us. 'Look, the cupboard!' one of them whispers. 'You can damn well wait till we are gone! You will have enough time to plunder then.'

Stories from Libussa Fritz-Krockow, Pomerania

Left:
Effigies of members of the Mecklenburg ducal line in the Gothic cathedral, Güstrow

Opposite:
The vast Renaissance schloss was used as a summer residence by the Dukes of Mecklenburg. In 1811 Napoleon's troops set up a field hospital in the palace on their epic march to Russia, and during the Second World War the Nazis used it as a prison, destroying what little was left of the original furnishings and decor.

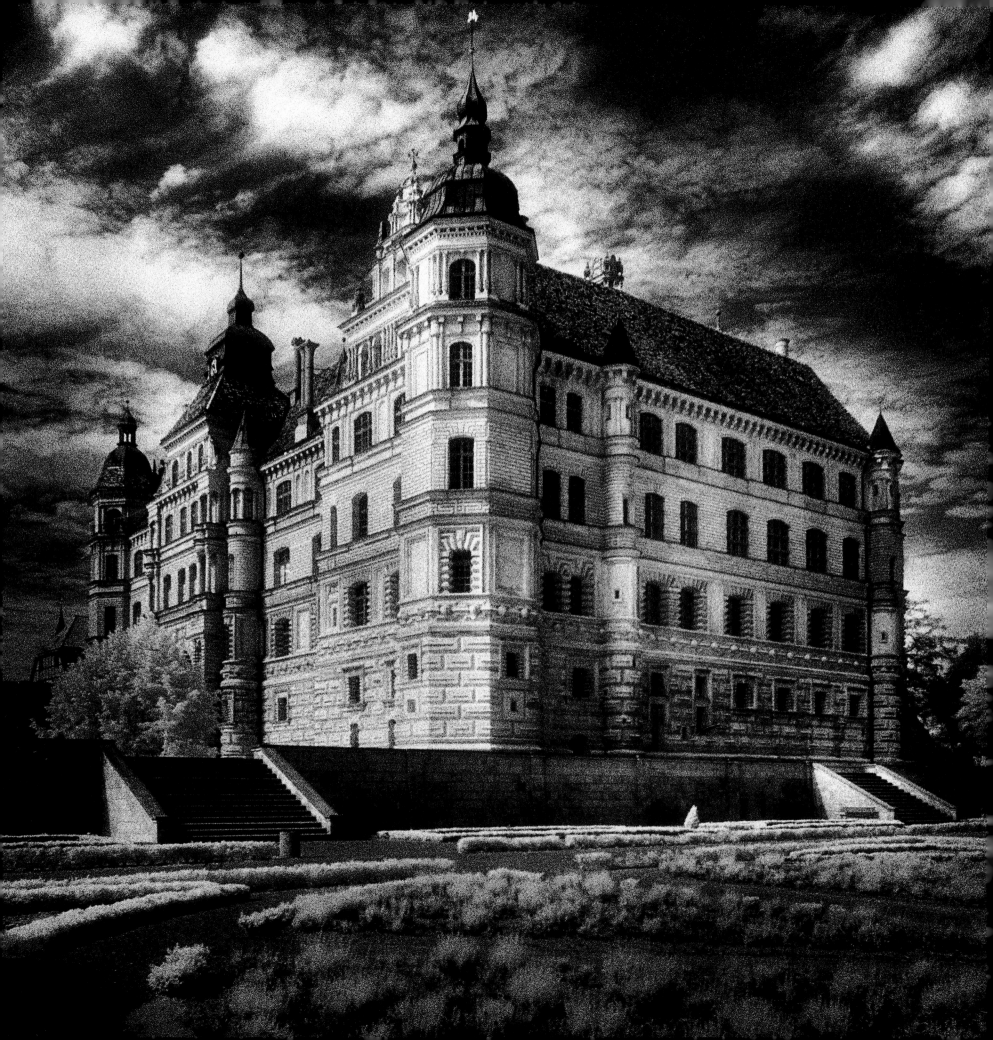

Schloss Schwerin

On 15 May 1945 we were invaded by a division of the Russian army; during the night an alarm sounded and the division departed. Two days later we were invaded by the occupational troops. During the first night seven refugee women were raped; one was a fifteen-year-old girl from the crown land lessee estate. The women fled to Schwerin that night to seek refuge with the English. The gamekeeper was stabbed 100 kilometres from his home. We found him after eight days and buried him.

The same night, the deputy gamekeeper and his wife were coaxed into a cellar and shot. We guessed that eastern workers had denounced them. I was arrested by the GPU, who wanted me to confess where I had hidden some arms and whether I had worked with the Gestapo. I couldn't confess to either accusation.

Weissbuch Nr 44 (R.T.)

The estates of Repritz and Lühburg were confiscated. Renata Gräfin von Bassewitz and her family were exiled. In all of the horror the only story she used to recount was of a family who like her own had had to escape. There was such confusion when they left in April 1945 that the only thing they took as the Red Army advanced was the key to the larder.

This anecdote from Renate Gräfin von Waldersee, born Renata Gräfin von Bassewitz, was told to Duncan H. McLaren by her son, Conrad Graf von Waldersee.

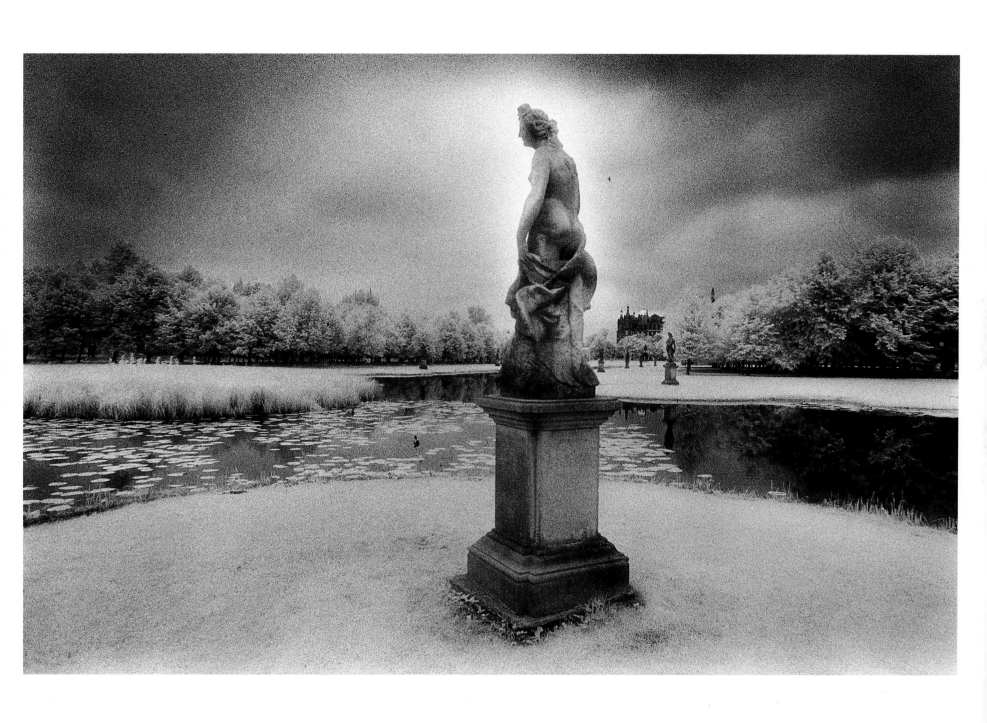

Schlosskapelle, Schloss Dargun

The magnificent schloss was built from the foundations of a former abbey by Herzog Gustav Adolf in the seventeenth century, but was gutted by fire in 1945. As I wandered through the crumbling walls of the mansion that had played host to Czarina Katherina in 1712, I eventually found myself in the great chapel. Twilight was descending as I gazed up through the arches. It was as if the sky had fallen on a sublime epoch.

Simon Marsden

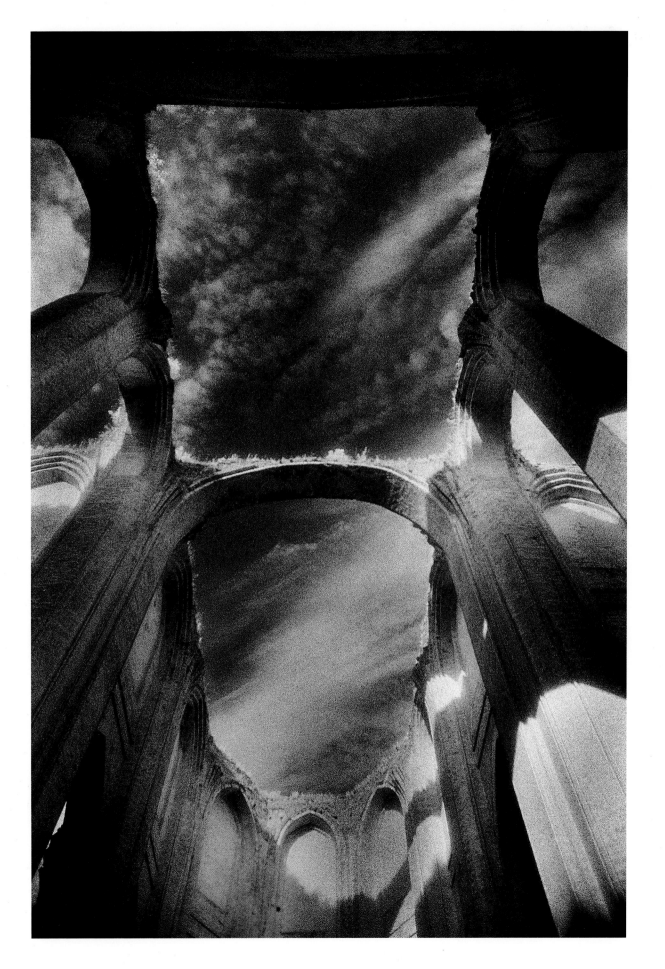

Schloss Basedow

It is always hard to imagine what the future holds in store for us. The child is lying outside the gardener's cottage in its little Moses basket on a beautiful summer's day. A Russian approaches on horseback – a stranger, not the friendly one from next door. He dismounts, studies the child, and takes it into his arms. He says, 'Beautiful child. My Matka no child. Matka always sad.' Holding on to the child, he mounts his horse again and disappears in the direction of the village.

I hastily pursue him, in my present state, half dressed and barefoot. The rider has already disappeared, but the people point the way. 'That way, he went that way!' I run along the entire length of the main street in the village, past the last houses, into the fields. Finally I spot the man. He looks in horror at the child, who screams blue murder, while his horse grazes peacefully at his side. As soon as I catch my breath, I explain to him that the child is hungry and needs to be fed. He nods his head in ready agreement.

I run home as quickly as my feet will carry me. The whole incident didn't last for more than quarter of an hour. Only now do I feel the shock waves take possession of my body; my body collapses, I cry – but we are safe.

This evening and all following evenings we lock our door, something we never did before. I remain dressed and ready to hide at a moment's notice. We have devised a plan to gain time in the moment of truth: Mother will open the door slowly and create a lot of fuss, while I escape through the back window with the child and hide in the park; yet I'm convinced that this will not be necessary. It had been very obvious that the man had acted hastily, without thinking about his actions. He had already come to his senses at the end of the village, where I had found him. How was he going to feed and take care of a child until he was reunited with his Matka somewhere in his homeland? And what would his superiors say? I very much suspect he already felt embarrassed about his actions. But we will never know for sure.

Stories from Libussa Fritz-Krockow, Pomerania

Opposite:
Schloss Basedow was the home of the von Hahn family from the fourteenth century. After the horror and destruction of the war, the building was in a perilous state. After expropriation in 1945 the castle was used for housing, and the great stables and riding hall as storage for a farming co-operative. The once beautiful park, designed by Peter Joseph Lenné, remains overgrown, a magical playground for the children from the village.

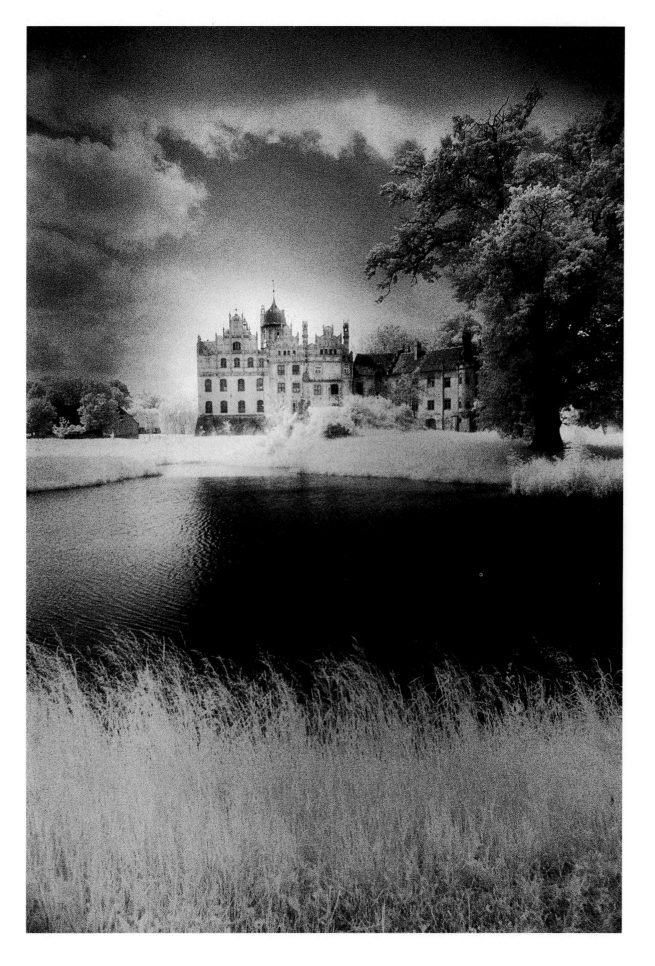

Klosterkirche, Bad Doberan

My estate was occupied by the Russians on 1 May 1945. Since all the alcohol had been drunk by the first lot of plunderers, two Mongolian officers who came the day after found not a drop. Out of sheer anger, they set fire to the manor house, and told us that they would shoot everyone who tried to extinguish it. The manor house burned down completely. I moved with my family into the village, where we spent the first night with the children in primitive circumstances. I only escaped being shot by pretending to work as a farm hand. My people didn't tell on me. When this was not possible any longer, I walked to Rostock. My wife managed to get to M. with the little grandchildren. These were hard times, since most of our neighbours were either shot or killed themselves.

Weissbuch Nr 74 (B.D.)

The fourteenth-century Gothic minster in Doberan was the principal resting place of the Dukes of Mecklenburg. The magnificent and imaginative seventeenth-century memorial chapel to Duke Adolf Friedrich von Mecklenburg (left) and his wife, Duchess Anna Maria (opposite), includes their life-sized wooden statues in the luxurious garb of their time, carved by the Leipzig sculptor Franz Julius Döteber.

Overleaf:
Schloss Wernigerode

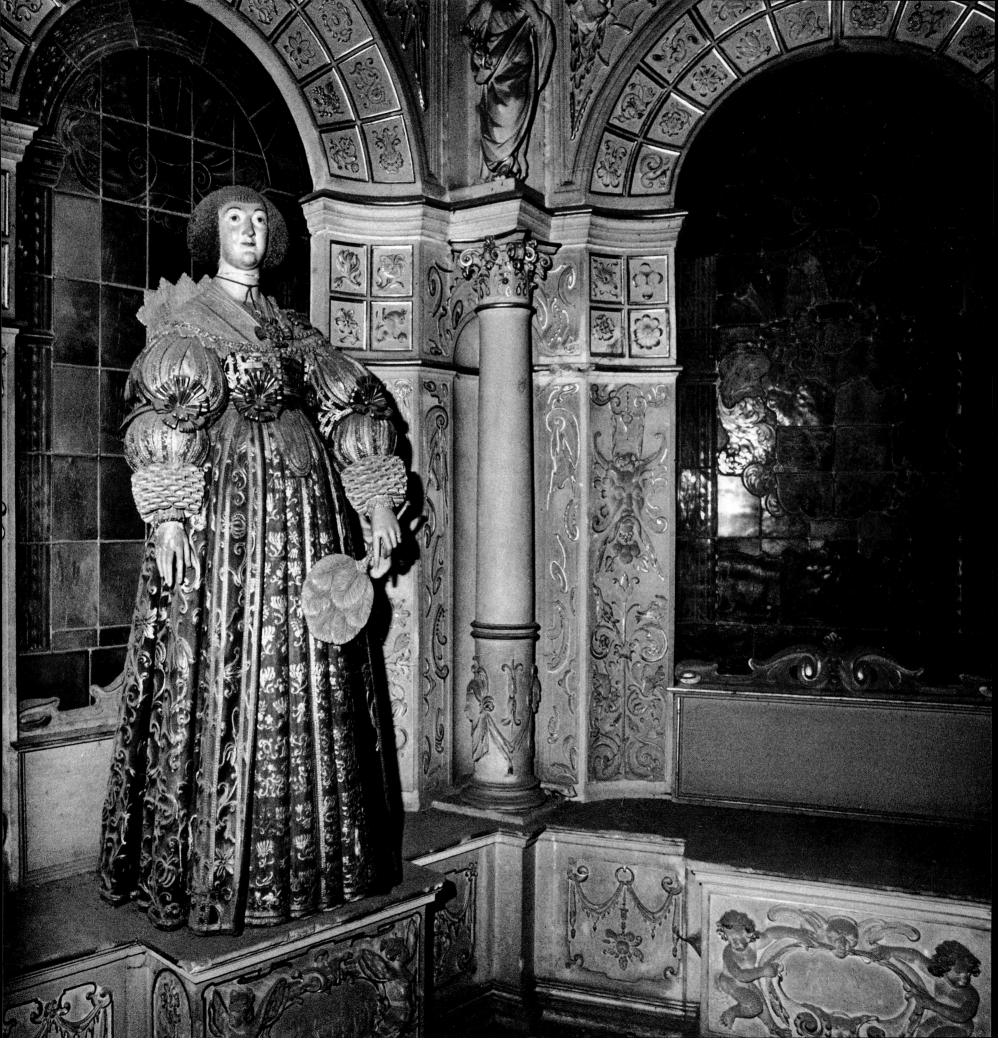

Sachsen-Anhalt

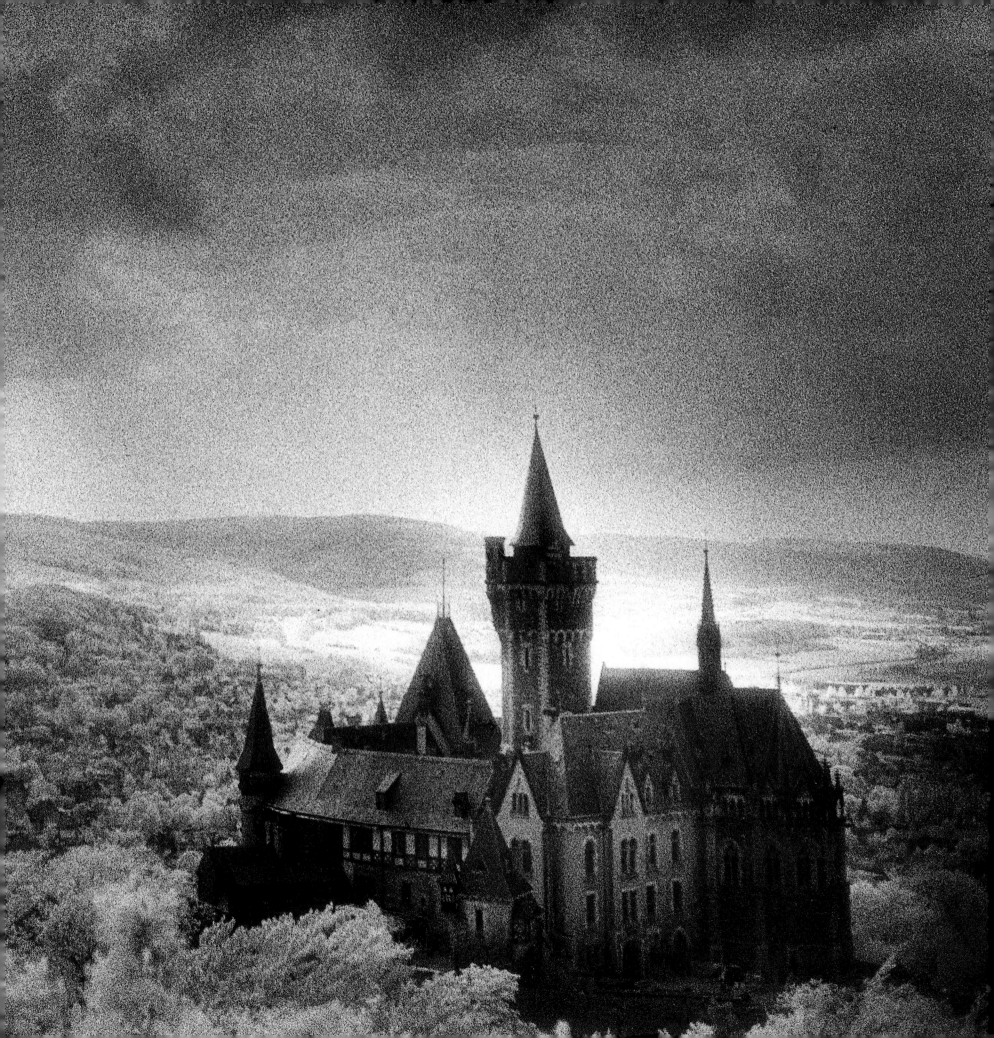

Schloss Burgscheidungen

The great house of the Schulenburgs stood empty. There was little or no furniture in the place. It was well kept, but for whom? The road ran up the hill through the village to the huge archway and the gates leading to the schloss, the gravel sweep and the view – the spectacular view. The garden fell away, green banks set with statues cascaded gently down to the trees, paths and pavilion that lay far below. The broad paths criss-crossed the wood, in one instance passing a very derelict summerhouse. Palladian it had been and so beautiful even in decay. A river meandered by. This was property maintained but dead. There were no people, no dogs, no laughter, no planning or replanting – nothing. But it was still there, waiting for something to happen . . .

Duncan H. McLaren

Left:
A sculpted head above
a doorway, Schloss
Burgscheidungen

Opposite:
The Terrace. After the
expropriation of the von der
Schulenburgs in 1945, the
schloss was used as a holiday
camp for children of the
Soviet army, and later as a
conference and educational
centre for the Communist
government.

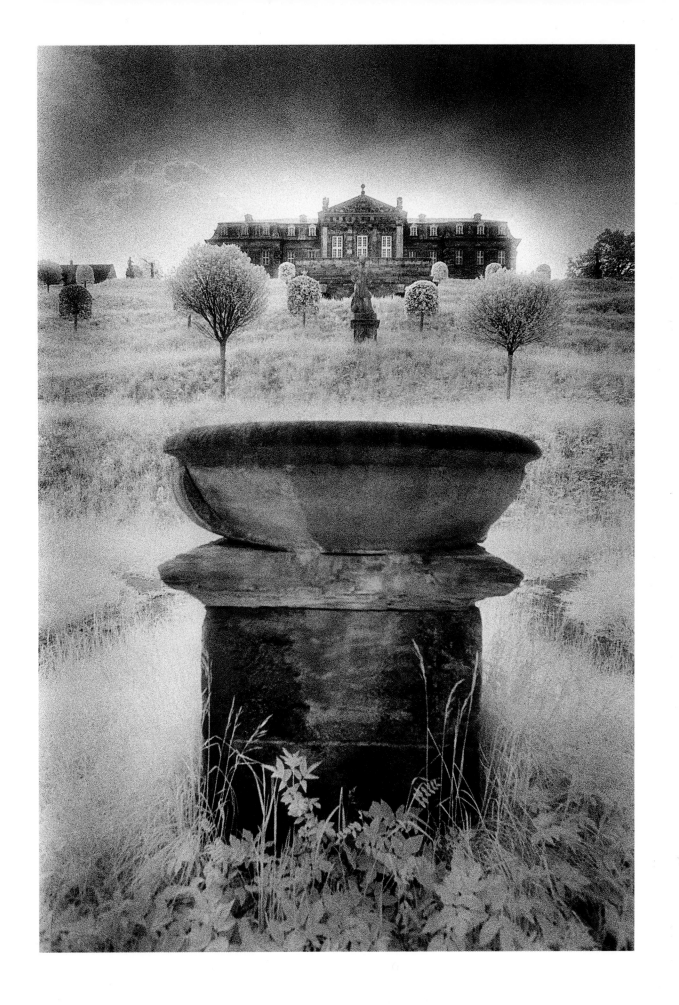

Schloss Königsborn

At lunchtime on 21 October 1945 the mayor phoned me to say that the Russian commander wanted us off our estate within two hours. After a couple of minutes, plundering hordes appeared. They sent the most vile people from the village, those to whom they had promised land. They had been given permission to steal. A Russian soldier ripped all the keys out of our hands. The others took furs, furniture and jewellery right from under our noses. We were only allowed to take food for two days. Valuable books were burned on the nearby fields, including all works by Schiller and Goethe. The pictures of our ancestors were ripped out of their frames and replaced with pictures of Stalin. One of our horses was slaughtered for the 'victory party' and given to the population. We were told to report to Torgau within twenty-four hours. We lived for a couple of weeks secretly with relatives in Halle, where we changed quarters frequently. A policeman phoned us and said that they knew where we were staying. He had been given the order to bring us into a concentration camp. We changed quarters that night and fled to the West via Ilsenburg.

Weissbuch **Nr 88 (T.H.)**

Opposite:
The last owners of the schloss, before their expropriation in 1945, were the family Naue. The schloss was made into an old people's home in 1948, but was later abandoned and fell into a ruinous state.

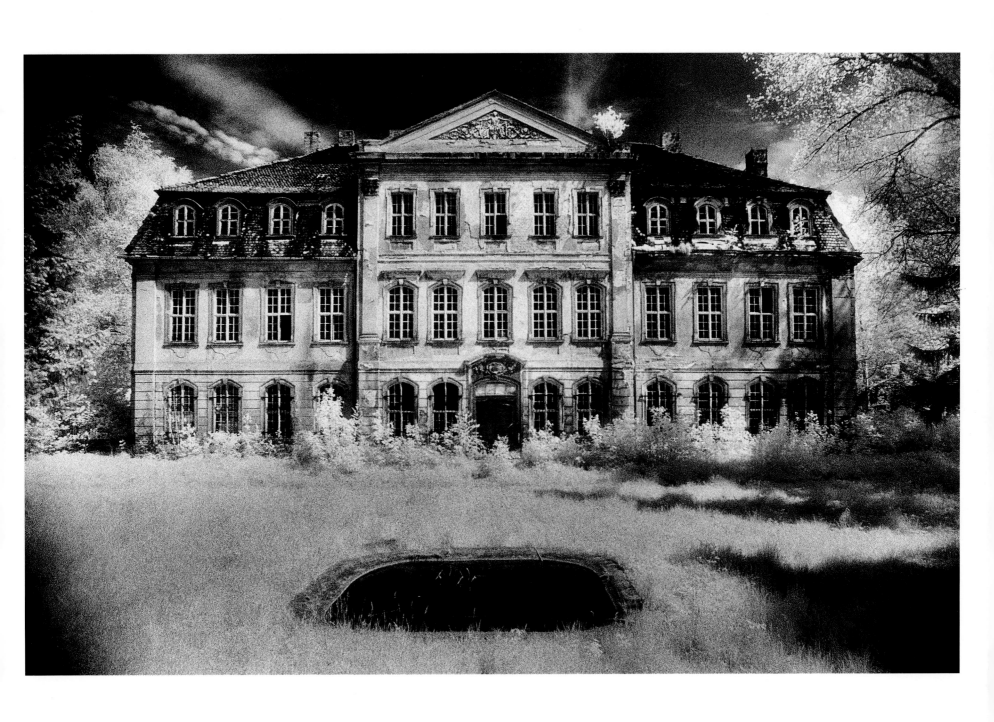

Burg Falkenstein

Lothar Graf von der Asseburg-Falkenstein-Rothkirch, my father-in-law, told me how, with his brother, he had buried a chest containing the most valuable silver and gold belonging to the Asseburg family in the woods near their old home, Falkenstein Castle. In the 1980s the thought of crossing into Communist-held East Germany and retrieving the treasure remained only a dream, but in the early months of 1990, as the two German states moved towards unity, I began to plan my moves carefully.

Learning the directions by heart, I chose the night of 7–8 April, a full moon, and crossed the East German border at Sorge. By 6 p.m. I was approaching the castle, searching for the old oak tree from which I should take my bearings. The shooting season had not yet begun and any chance of meeting gamekeepers or woodcutters in the forest seemed remote. I discovered not one oak but two. Measuring 18 metres from the right-hand tree, I began to dig, pausing every now and then to listen. By midnight I had found nothing. Tired and dejected, I covered up my diggings, watched by a passing stag before he bounded silently away.

Once back at home I applied for a visa, and bought a good-quality metal detector. I planned the second trip for 26 May and took a trustworthy friend as a look-out. We took it in turns to dig near both oaks, but after many frustrating hours were forced to call it a day and cover our tracks once more. However, I remained determined to try again at the earliest opportunity. My chance came four weeks later, when Germany were due to play Holland at football in the World Cup Final. The area would be deserted and the borders quiet; all I needed was my dog, Seppel. But again my metal detector failed to locate the box.

Opposite:
In the fifteenth century the castle came into the possession of the Asseburg family, who lived here until the end of the Second World War. Hidden from the outside world, it lies in the middle of a forest perched on a rock 305 metres above sea level.

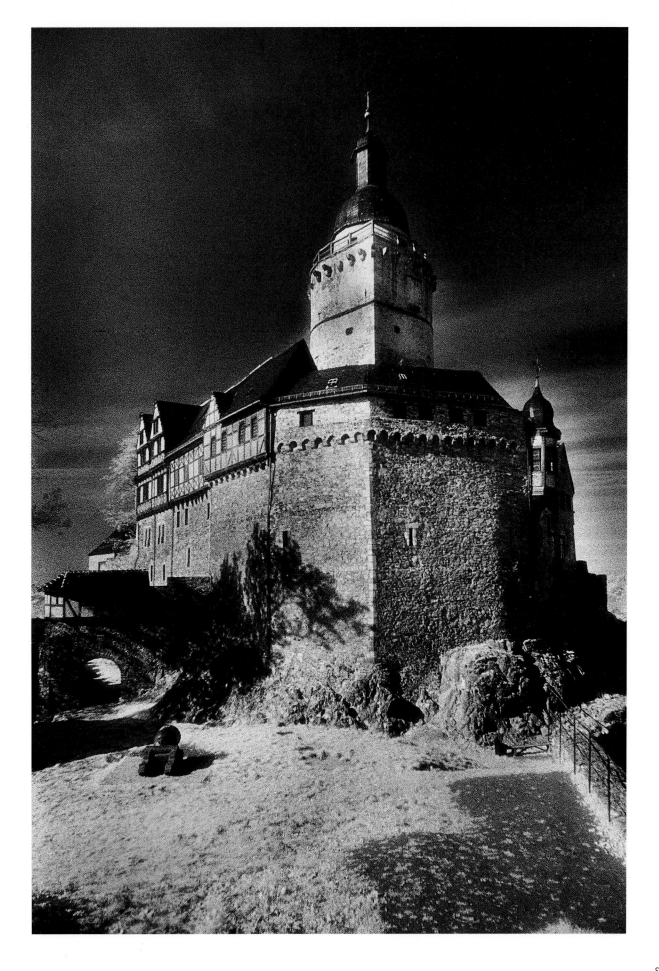

Becoming despondent, I began to question the information I had. Could it be that I had been looking in the wrong place? Widening my search area, I came across the burnt-out stump of an oak. My metal detector immediately gave off a strong signal, it was not long before my spade scraped against the top of the chest, and minutes later I was gently lifting the lid to peer inside. The damp of forty-seven years had rotted the packaging, but the fabulous hoard of treasure was otherwise intact. Elated, I filled in the hole, and carried the valuable contents to the car, where I hid them under a sleeping bag on the back seat, guarded by my dog.

I nervously approached the border around 3 a.m., but the lone guard was disinterested and remained in his hut. In 80 metres I was back in West Germany. The most precious item of the treasure was the Asseburg crystal tumbler, brought back from the Crusades. A part of the family's heritage had been regained.

I am recording these events while they are still fresh in my memory.

Peter Vickery, 1 July 1990

Opposite:
This ornately carved bed is said to be haunted by the White Lady of Falkenstein. Another legend told of a shuttered room that held a mysterious secret – a great catastrophe would befall the family if it was opened. In 1945 the door was smashed down by drunken American soldiers, and at exactly the same moment the Earl's grandmother died. Within weeks the rest of the family were forced to flee the castle and the Fatherland.

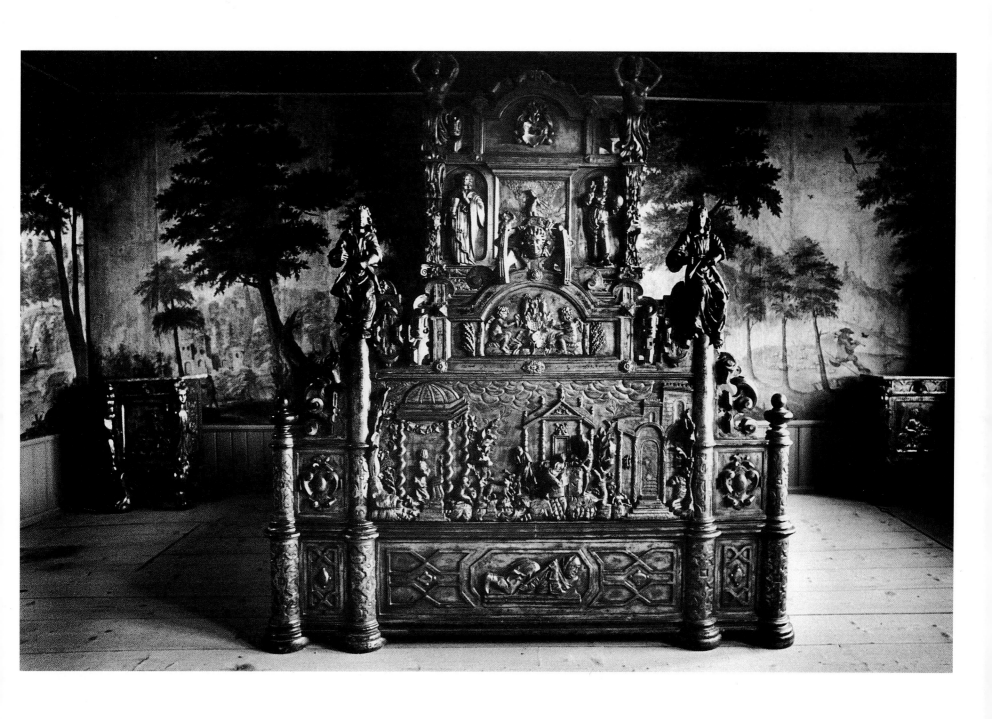

Schlosskirche St Trinitatis,
Schloss Neu Augustusburg, Weissenfels

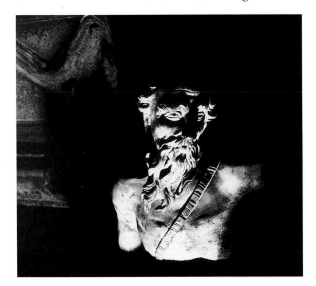

From 1664 to 1694 a vast Baroque schloss was built for the powerful Dukes of Sachsen-Weissenfels. Now the only part of this great seventeenth-century palace that retains its original features is the chapel, the last early Baroque castle church existing in Middle Europe today.

The shell of the chapel is Renaissance, and is rich in Italian stucco work, marble statues and biblical paintings. In front of the altar, under a carpet, lies a trapdoor, the entrance to the Ducal Tomb containing thirty-eight sarcophagi of the Sachsen-Weissenfels family, whose line had become extinct in 1746. Their vast stone coffins are adorned by ornate statues, skulls and heraldic emblems. These silent, often macabre, memorials and their aristocratic cadavers, lie forgotten in the dark vault, relics of a more certain age.

Simon Marsden

Left:
A statue adorning a sarcophagus in the Crypt, Schlosskirche St Trinitatis

Opposite:
Sarcophagi in the Crypt, Schlosskirche St Trinitatis. By 1815 the palace had been turned into a Prussian barracks and much of the lavish interior decoration was destroyed. From 1945 it was used by the Communists first as a refugee camp and later as a school.

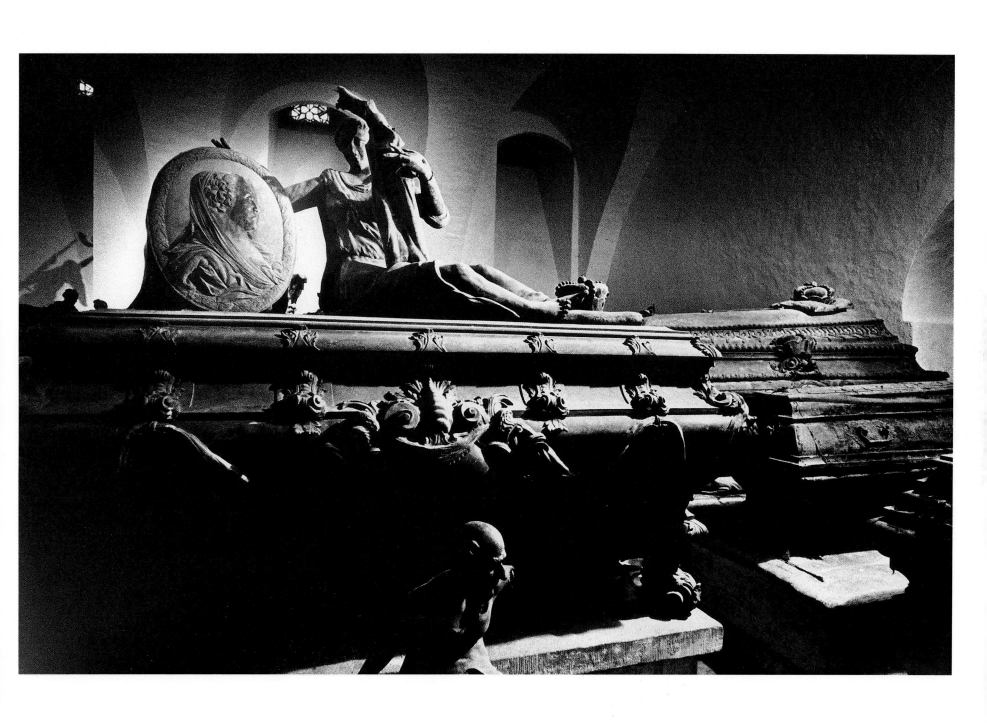

Schloss Hohenerxleben

The courtyard was cut off by high wire fences. The house had an institutional air that hung heavy on the turrets and roofs that had known another, more charmed life as the home of the von Krosigk family since 1738. There was plaster on the walls below the bay windows — much had fallen away. Slats of wood showed between the remaining swirls of the grand beige design. We could get no nearer. We found an overgrown path to the right of the house, and stumbled along the steep alley of laurels to the grass banks below the schloss.

Two black ponies suddenly appeared from nowhere. It was a magnificent sight: the long grasses, the flowers of May and the water meadows below the ponies, the tall house above. Perhaps this was another time and two children would come to ride their matted black friends. But it was not to be. No children came. The laurel alley returned us to reality and we passed back into the world of high fences.

Duncan H. McLaren

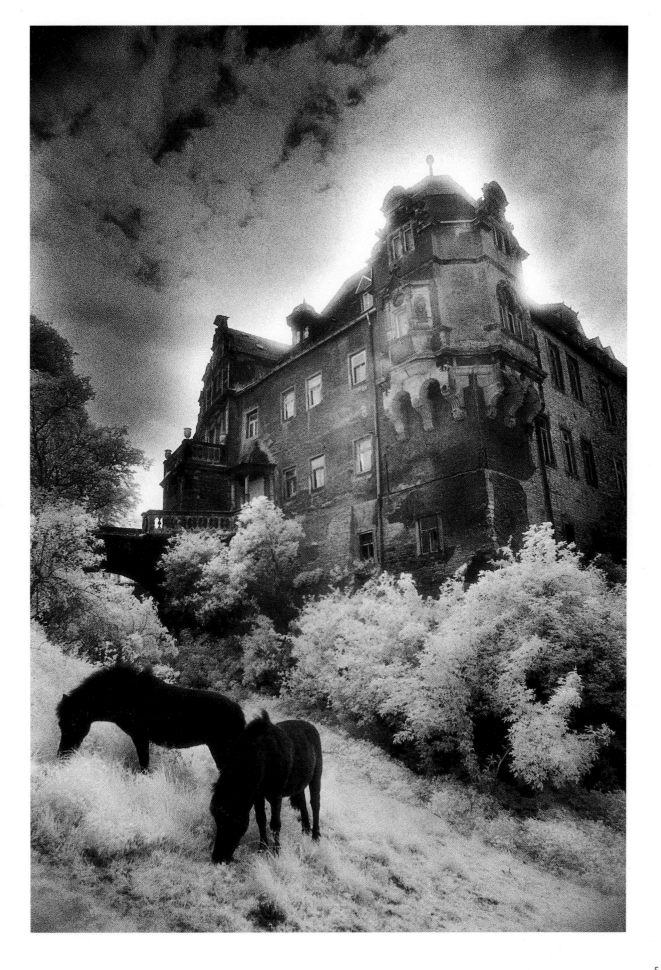

Schlosspark, Wörlitz

This garden paradise was the fantasy of Prince Leopold III, Friedrich Franz von Anhalt-Dessau, an enlightened, progressive ruler. It was Germany's first landscape garden in the English style; the neo-classical schloss was inspired by Claremont Castle in Surrey.

Goethe visited Wörlitz in 1778 and was enchanted by its beauty, describing the park as having the character of Elysian Fields. In the same letter to Charlotte von Stein he wrote how 'the gods had allowed the prince to create a dream'.

Under the Communists the park was neglected, overgrown. Now the follies, temples and vistas are coming to life once more.

Simon Marsden

Left:
Rousseau Island. A solitary funeral urn stands surrounded by poplars in the middle of a small lake in homage to Jean-Jacques Rousseau, the French philosopher of 'nature pure nature', a founder of the Romantic Movement in the eighteenth century.

Opposite:
A classical temple. The park was laid out between 1768 and 1800, a mixture of Renaissance and Gothic styles.

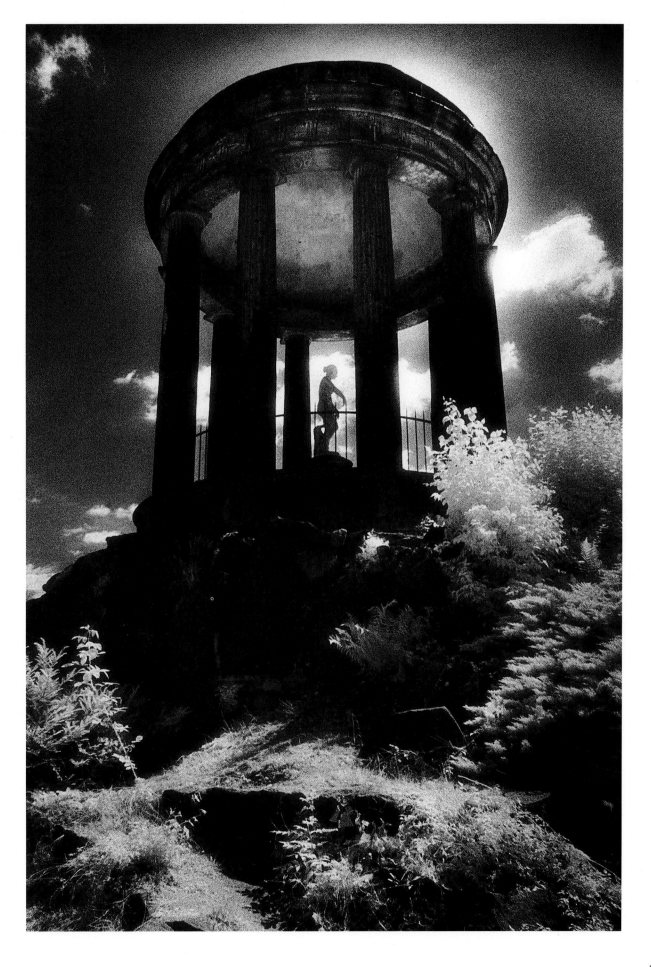

Schloss Zerbst

I was beginning to set up my tripod when a colourful procession of jugglers, clowns, musicians and fire-eaters approached the ruin. As they circled the building, they were followed by a group of young children singing and laughing. It must have been a pageant or festival of some kind. As the echo of their celebrations eventually faded away, an eerie silence settled upon the building once more.

The vast schloss, the principal seat of the powerful Anhalt-Zerbst family, whose line had become the extinct in 1793, was destroyed in 1945, and now only the east wing remains. As I pressed the shutter of my camera, the fraction of a second sounded like an eternity.

Simon Marsden

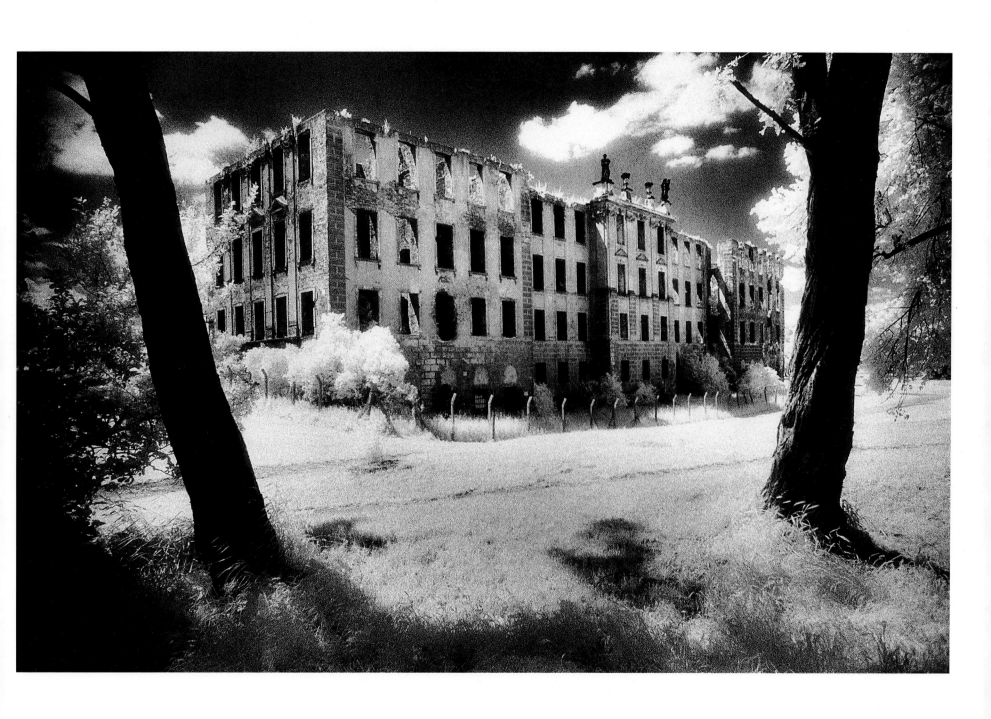

Schloss Vitzenburg

The lunatic asylum rose high above the terrace of thick grass. I stood on steps cracked and broken, which ascended to the columns and glassless panels of the long disused winter garden. I looked up. An arm extended through the bars of a window; all that could be seen was a hand frozen like an open fan. A cry came from within. I moved on and around the towers of Schloss Vitzenburg.

In 1127 a klosterkirche was built here. This kloster later became a castle and the first people known to have lived in it were the great Lords of Schulenburg. One of the Schulenburgs – the last – had two daughters, one of whom married a Baron Heyno Münchhausen.

We stayed in a little hotel run by Rüdiger Wirthmann, whose grandfather had been the Münchhausen family's coachman. During the Second World War it had been a restaurant owned by Rüdiger's father, who was forced to flee in 1953. Rüdiger came back in 1992 and restored the ruined building. The church for the estate is still a wreck. The local bishop will not allow the people of the village to restore it, and the church does not have the money for repairs. Rüdiger's parents were married and his sisters baptised in the church. He says his heart is 'bleeding' to see it in such a state. Rüdiger is having a tough time in the East but he will stay.

Before the Münchhausen family fled, they buried the family silver in the castle grounds. This was found some years later by local children who were playing there. It is now in the museum at Burg Querfurt. The staff of the castle and the people of the village stripped the castle of its furniture after the Münchhausen family left, and much of it still remains in the houses of the surrounding area – according to local hearsay. Now Heyno's son is eighty years old and lives near Hanover. He recently visited the castle and tried to buy it back, but this proved impossible. Time had moved on.

Duncan H. McLaren

Left:
A statue in the village church, Vitzenburg

Opposite:
Schloss Vitzenburg. Heyno Münchhausen was imprisoned and died in a Russian camp during the Second World War. Heyno's son fled the castle with his sister when the Russians advanced.

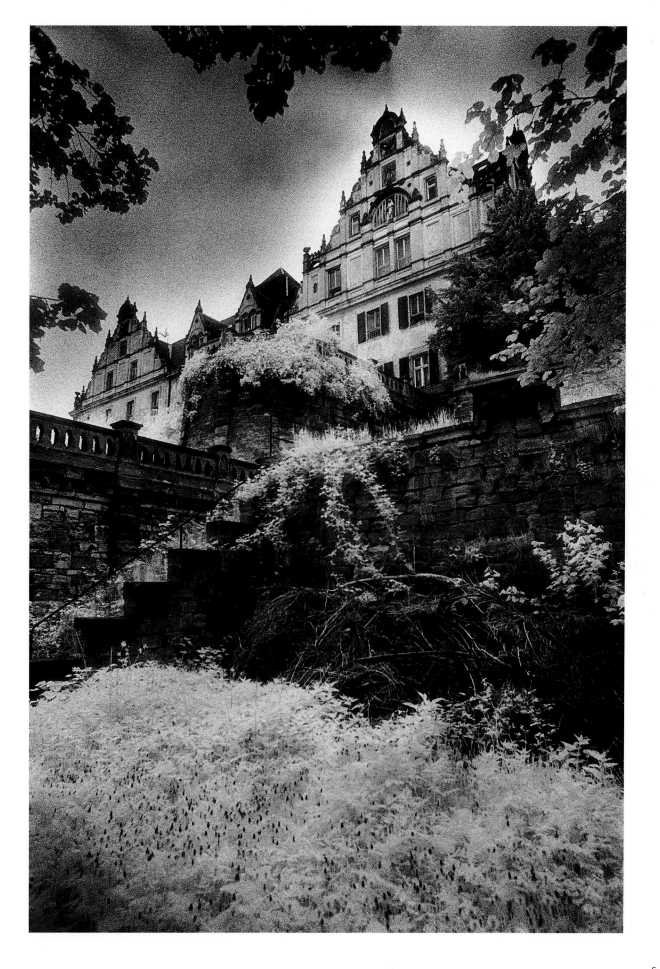

Schloss Bernburg

After the Russians had been in the country for three months, a mass of people appeared suddenly. They were led by a Communist, who acted as their speaker; next to him was a Communist mayor. The speaker told my wife (I was not at home that day): 'You are now expropriated. You don't own anything any more. From now on you have to live like everyone else. No rich food, no diamond ring will leave this house. You will be allowed to remain living here, if you behave decently.' I was treated respectfully at first, because I was known to have been anti-fascist, but that didn't stop them from arriving soon after the expropriation with twenty-three trucks to empty all the rooms, except for those allocated to me – only the bare walls remained.

On 2 January 1946 we received the written eviction order, which took effect on 15 January 1946. We thought this was a trick. By chance my daughter and I went to the district magistrate's office the next day, where we spoke to the secretary, who quite liked us. She told us that yesterday's order had already been revised, and would be announced to the district by the Communists. She whispered to my daughter: 'Go over the border tonight or tomorrow night at the latest'. Later we found out that the order to pack and to go to the station to be deported to a working camp had already been issued to us. With great difficulty we managed to leave the Russian sector and reach the border on 4 January 1946. We only just managed to save our lives and freedom. We had to leave everything else behind. This was the end of an estate which had been in the family for more than 500 years.

Weissbuch Nr 80 (B.S.)

Opposite:
The palace was the royal residence of the Princes of Anhalt-Bernburg from the middle of the sixteenth century until the extinction of their family line in 1863. Beneath the varied skyline of towers, turrets and gables the courtyard is peopled by statues bearing grotesque heads and heraldic emblems.

Overleaf:
A statue in the crypt of the Schlosskirche, Schloss Altenburg

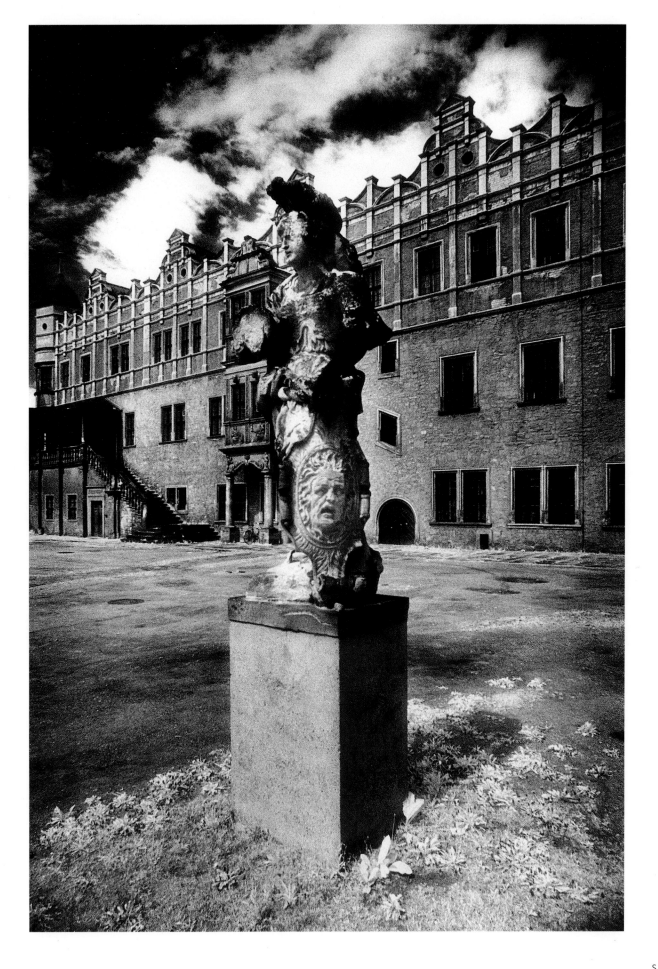

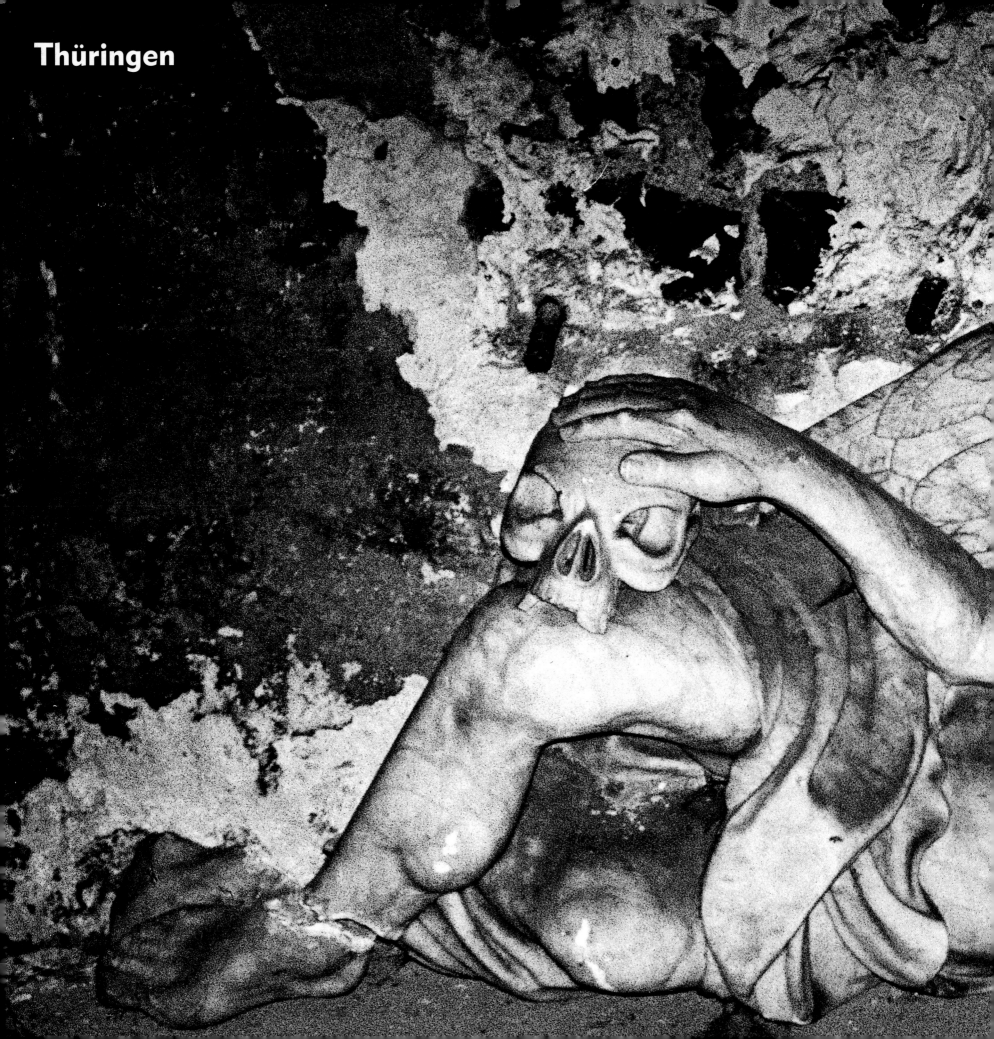

Thüringen

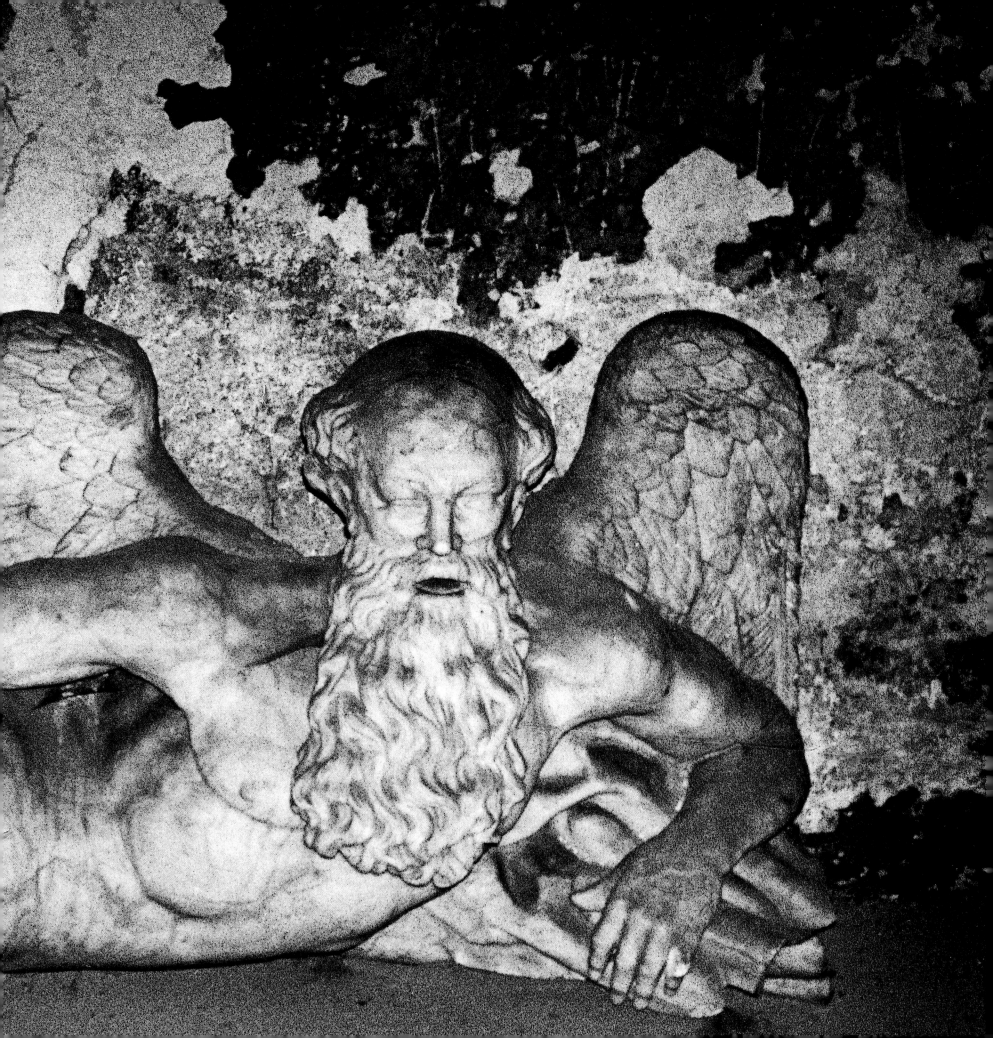

Monument to Emperor Frederick Barbarossa, Kyffhäuser Mountain

In the twelfth century, Frederick I, a Hohenstaufen, became Holy Roman Emperor, King of Germany and King of Italy, and was also known as 'Barbarossa' or 'Redbeard'. Legend says that this powerful monarch and fearless warrior still lies sleeping inside the Kyffhäuser Mountain and will rise again only after the final unification of Germany.

His likeness in stone was erected on the mountain towards the end of the nineteenth century. A massive tower rises above this seated figure amidst the ruins of Kyffhäuser Castle, an eleventh-century Hohenstaufen stronghold, and one of the largest fortresses in Germany.

Simon Marsden

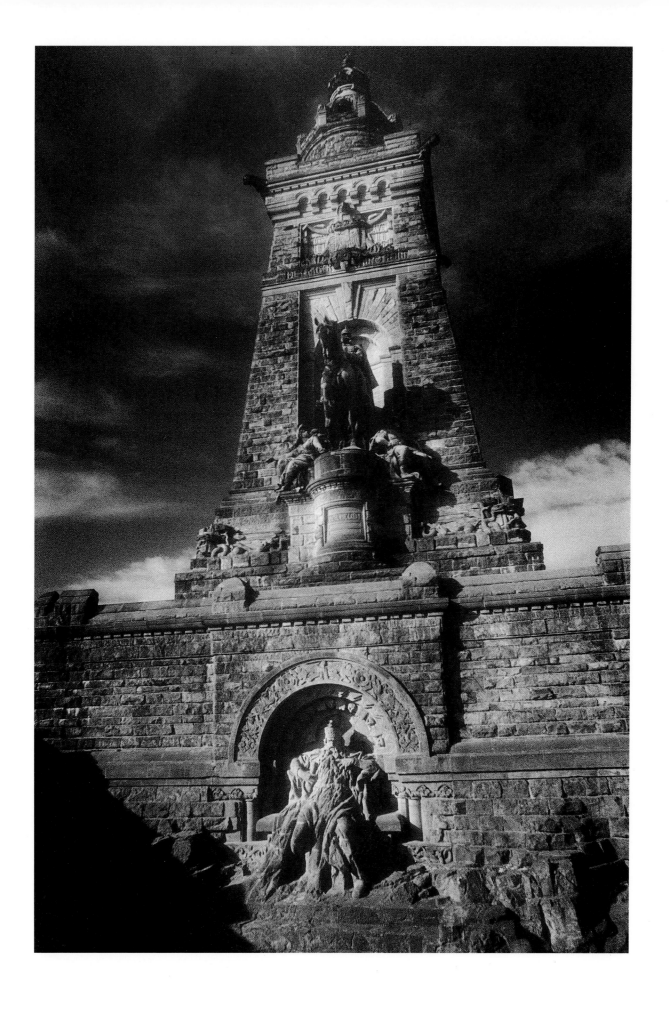

Burg Rothenberg

Climbing the steep path up to the castle, we met an old man, a woodman, repairing a fence. He identified it as Rothenberg Castle after its once powerful lords, the Earls of Rothenberg. They had fallen on hard times and it had been a ruin for many years. He told us the following legend that he said was centuries old.

When the Earls of Rothenberg were at the height of their powers, they employed an old woman from the nearby village of Kelbra to bring them their food. She would carry it up to the castle each morning, returning to the village sometimes in the afternoon, sometimes in the early evening and occasionally at midnight. If there was a full moon when she was going home, she would meet the ghost of Sophie, Countess of Rothenberg, wandering through the woods below the castle, for she could find no rest. The old woman always asked her how she could help her and why she was so distraught, but the apparition would only beg her to make the following promise: if she should meet a tall man wearing a long black cloak and leading a fierce hound, to be sure to ask him how much longer she must still wander abroad as a restless spirit. When the old woman later met and asked this of the mysterious man, he always replied, 'Just one hundred years more'.

Simon Marsden

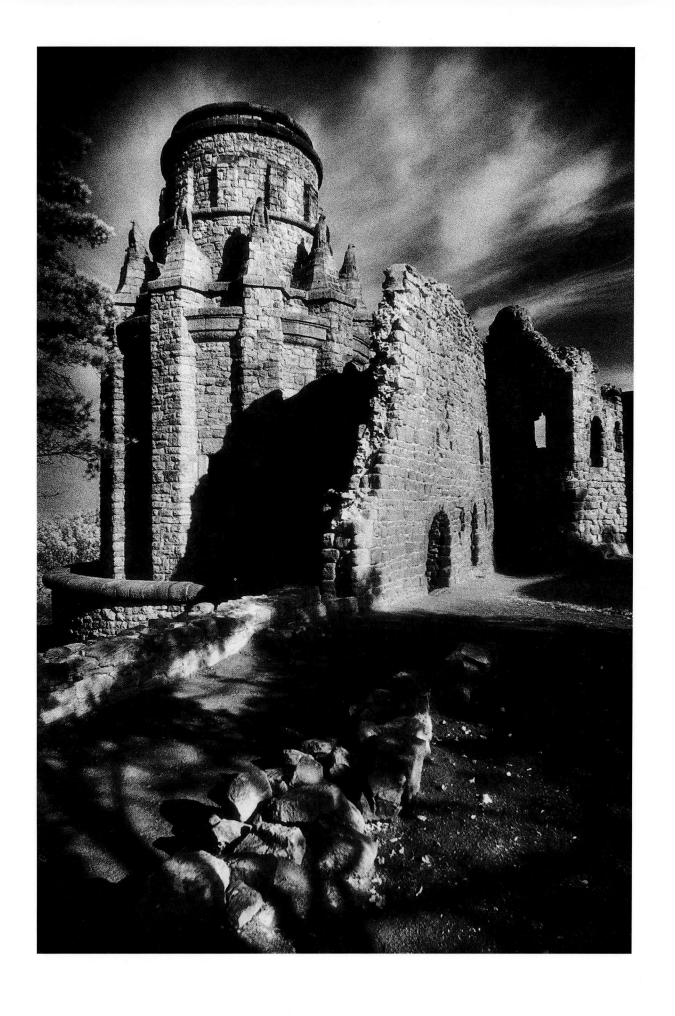

Sommerpalais, Greiz

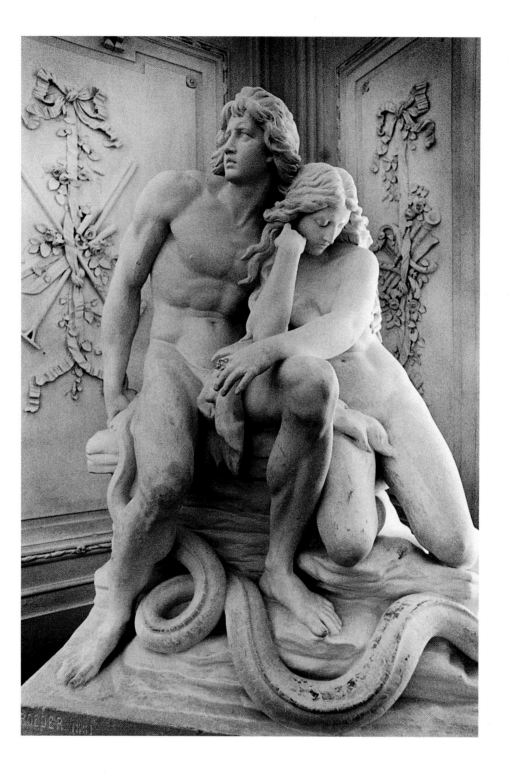

Left:
Adam and Eve and Serpent by
Carl Roeder (19th century)

Opposite:
*Dwarf on the Shoulders of a
Peasant* by Carl Roeder.
Greiz was the capital of the
senior line of the Dukes of
Reuss, who built their neo-
classical Sommerpalais during
the eighteenth century. It
stands in romantic parkland
and houses a magnificent art
collection, part of which came
to the Reuss family through
the Duchess of Reuss's
mother, Princess Elizabeth of
England, daughter of King
George III.

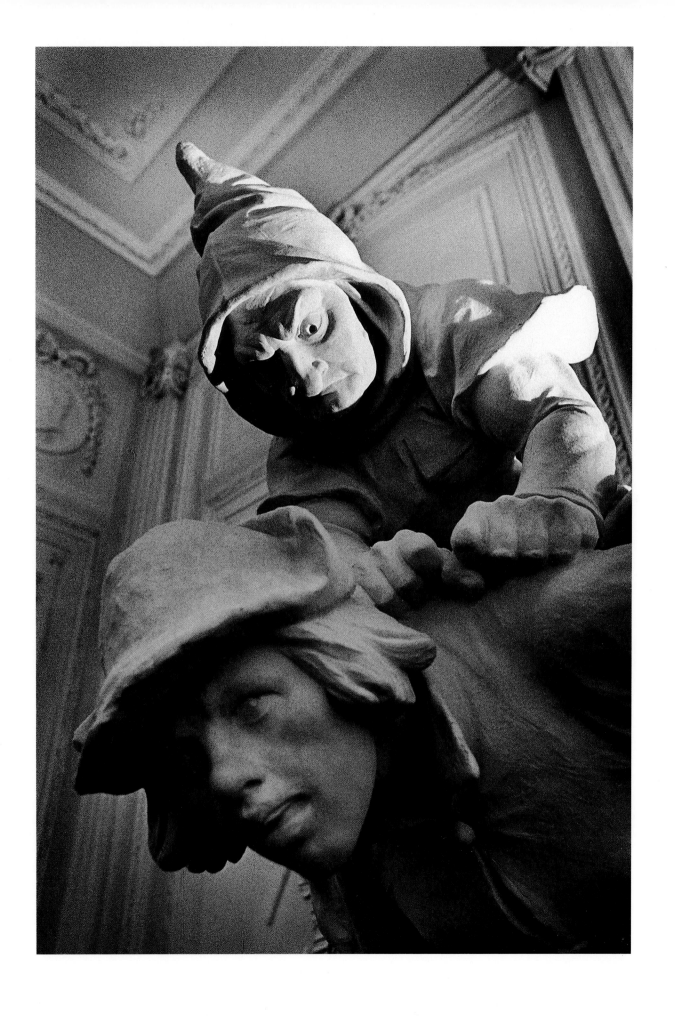

Schloss Oppurg

In one instance a local mayor in Thüringen delivered the expulsion order himself to a very old lady, whose sons had been killed fighting for the Fatherland. She lived alone and had no one to fend for her now. The workers and farm manager had gone; just one woman remained. The mayor left the order with her and said she had one day to leave.

The next day the soldiers arrived. She had not moved at all and was still in bed. At that point the soldiers picked up the bed and carried it downstairs and into the courtyard, with the maid screaming like a witch and the old lady sitting bolt upright and silent. They were then bundled into an open cart and, with little or nothing, taken to the local train station for deportation.

Duncan H. McLaren

Opposite:
Schloss Oppurg was the property of the von Hoym family from the eighteenth century. The oldest parts of the castle date from 1084. The daughter of the last owner married a prince, Lord Hoym von Hohenlohe-Ingelheim, but they were forced to flee in 1945 as the Soviets advanced. The schloss was then turned into a military hospital by the Russian troops.

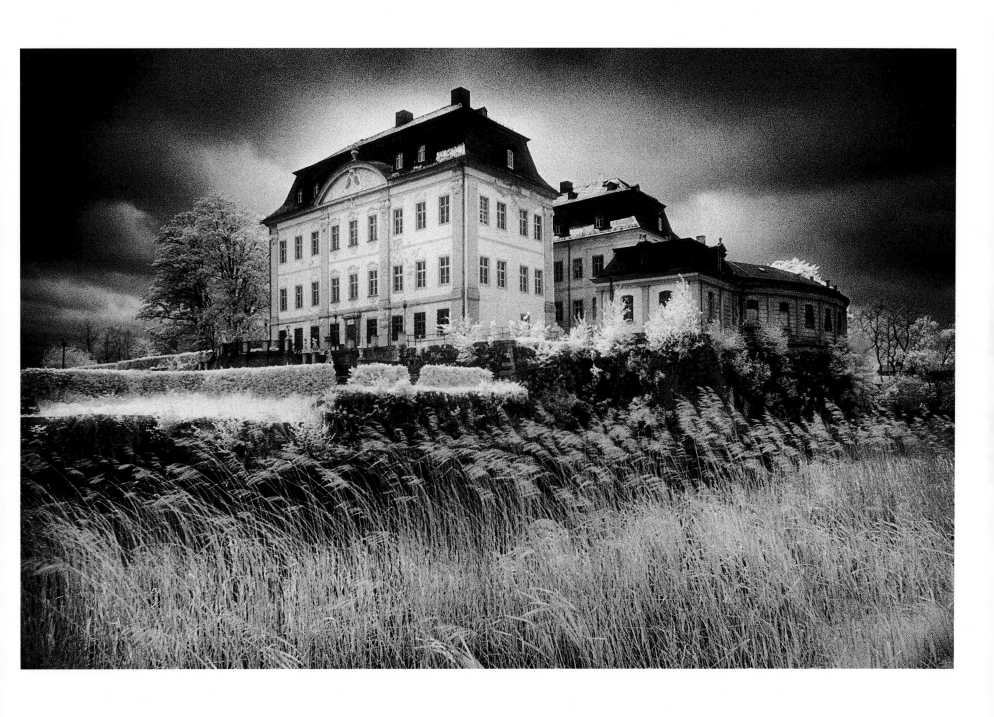

Schloss Friedenstein, Gotha

My whole property was expropriated without compensation during the agrarian reform. The district magistrate showed up on my estate in the middle of 1945 and told me that I had to leave the estate by that evening, my family had to leave within three days and I was allowed to take some necessary furniture. I was able to save very few objects; I have lost a collection of paintings, antiquities of all sorts, library, etc., of high value. I never received notification of the expropriation other than the verbal notification from the district mayor. I was told only by the tenants that the expropriation had taken place. Most of the estates had belonged to my family since ancient times, except one that could be traced back 700 years. The castle had been a listed building. It was torn down on Russian orders. Thirty-seven people were made homeless.

Weissbuch **Nr 135 (H.U.)**

Left:
The Festsaal or Ballroom.
This resplendent Baroque
palace was once the seat of
the House of Saxe-Coburg-
Gotha, the name of the
British royal family until they
changed it to Windsor at
the outbreak of the First
World War.

Opposite:
The Weimarische Galerie –
Gallery of the Weimar Period.

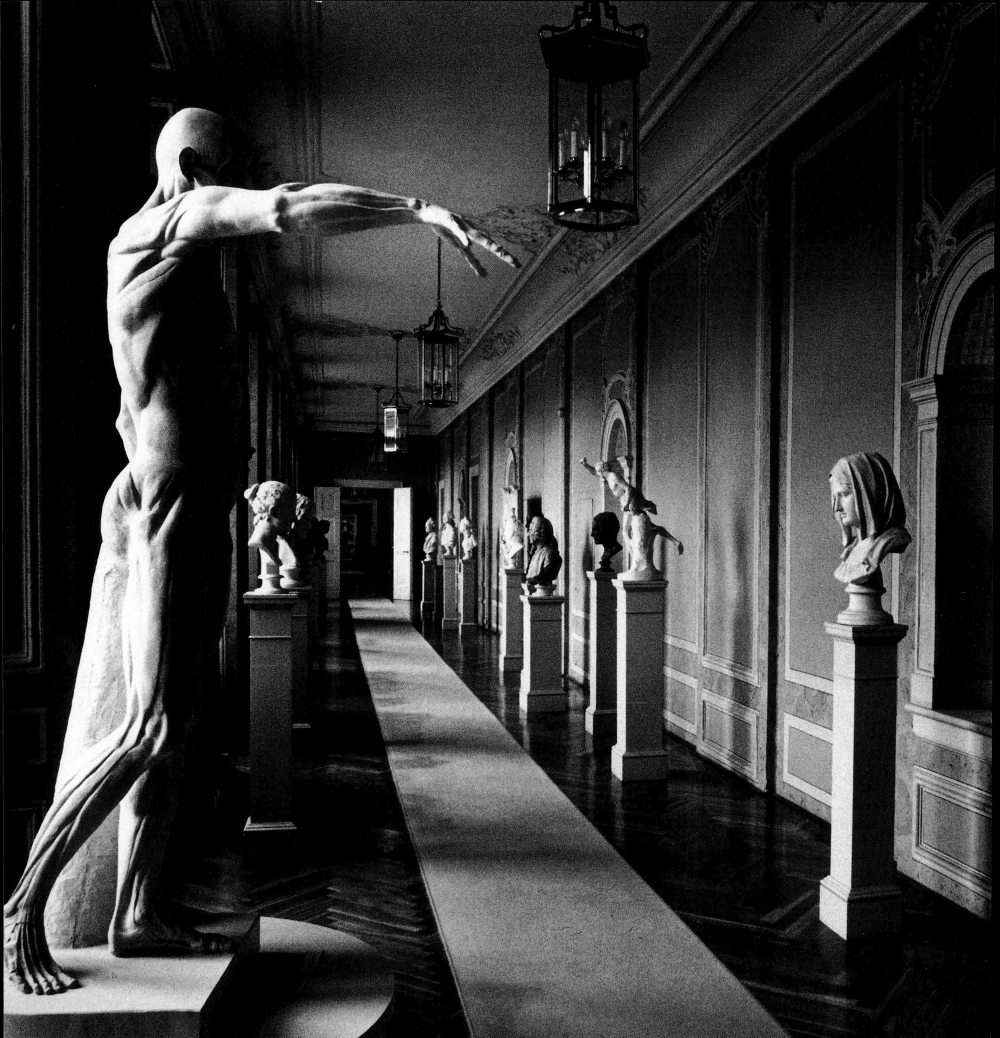

Villa Richter, Rudolstadt

Light from the sky falls where gaslight held sway. The rain splashed the leaves lying on the marble floors that spread away from the sweeping staircase that has vanished. No more the click of booted heel, just the rain. Some glass remains to keep the elements out of the otherwise glassless windows; saloons of burnt wood; doors of charcoal. Pipes, rusted, encircle the rooms under iron grills and mosaic floors that were installed for under-floor heating in the 1880s – in this dream house of a modern age. It survived the years of Soviet occupation only to be burnt by the liberating party when the Wall came down, because it was used as the Communists' local headquarters. The fates are strange.

Down the rotting staircase to the basement of this vast wrecked villa in Magdeburg, where Communist literature singed by fire or sodden with water was piled high in domestic rooms where bustle and industry once prevailed. Upstairs again, up and up to view the view. An iron spiral staircase leads to a porch, a vantage point from which to observe the ghastly grey of this vast industrial landscape. The wealth of the land was based on the huge expanse of fertile fields which stretched in every direction, the powerhouse of production, until division and redistribution of the land brought the destruction of profit.

Duncan H. McLaren

Opposite:
The owner of a local factory lived in Villa Richter at the time of its expropriation. The mansion, surrounded by haunting statues, is now a school.

Schloss Heidecksburg, Rudolstadt

At first we were occupied by the Americans, then the Russians invaded us on 11 July 1945. We didn't suffer. We were told of the expropriation by the Local Commission for the Accomplishment of the Agrarian Reform. We were asked to vacate the house at the same time. When we asked them where we should go, the only Communist in the village answered: 'You country squires should die on the streets'. My father-in-law, as the owner of the estate, was first brought to the prison in Teichwolframsrod, then to Erfurt, Camp Kalkreise, and later to the police prison in Erfurt. I had been on a trip away from home during that time and therefore managed to avoid being arrested. My wife and children fled in the middle of the night and hid with friends in the town. My father-in-law was kept in prison, although he was a recognised anti-fascist, since he was a member of the acknowledged church. He was released in 1946, but remained in the Soviet sector. They 'found' ten guns on his estate in May 1946, although he had been forced to leave the estate six month earlier. He was re-arrested by the Russians and died from starvation at the Buchenwald concentration camp in August 1948.

Weissbuch Nr 138 (U.L.)

Left:
Effigies of the von Schönfeld family by Nicholas Bergner in the Stadtkirche, Rudolstadt

Opposite:
The Marmorgalerie – Marble Gallery. The castle belonged to the Counts of Schwarzburg in the fourteenth century. After a great fire in 1735 it was rebuilt in the extravagant Dresden Rococo style by Friedrich Anton. In the eighteenth and nineteenth centuries literary and musical figures such as Schiller, Goethe, Wagner, Liszt and Paganini all spent time here.

Overleaf:
Effigies of the von Einsiedel family, Dorfkirche, Gnandstein

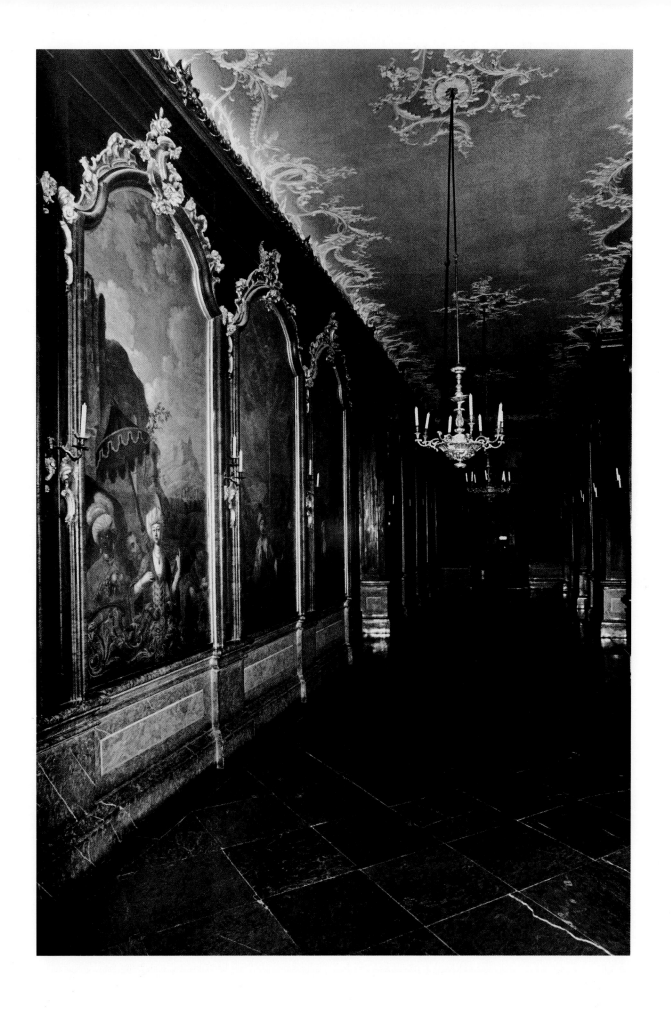

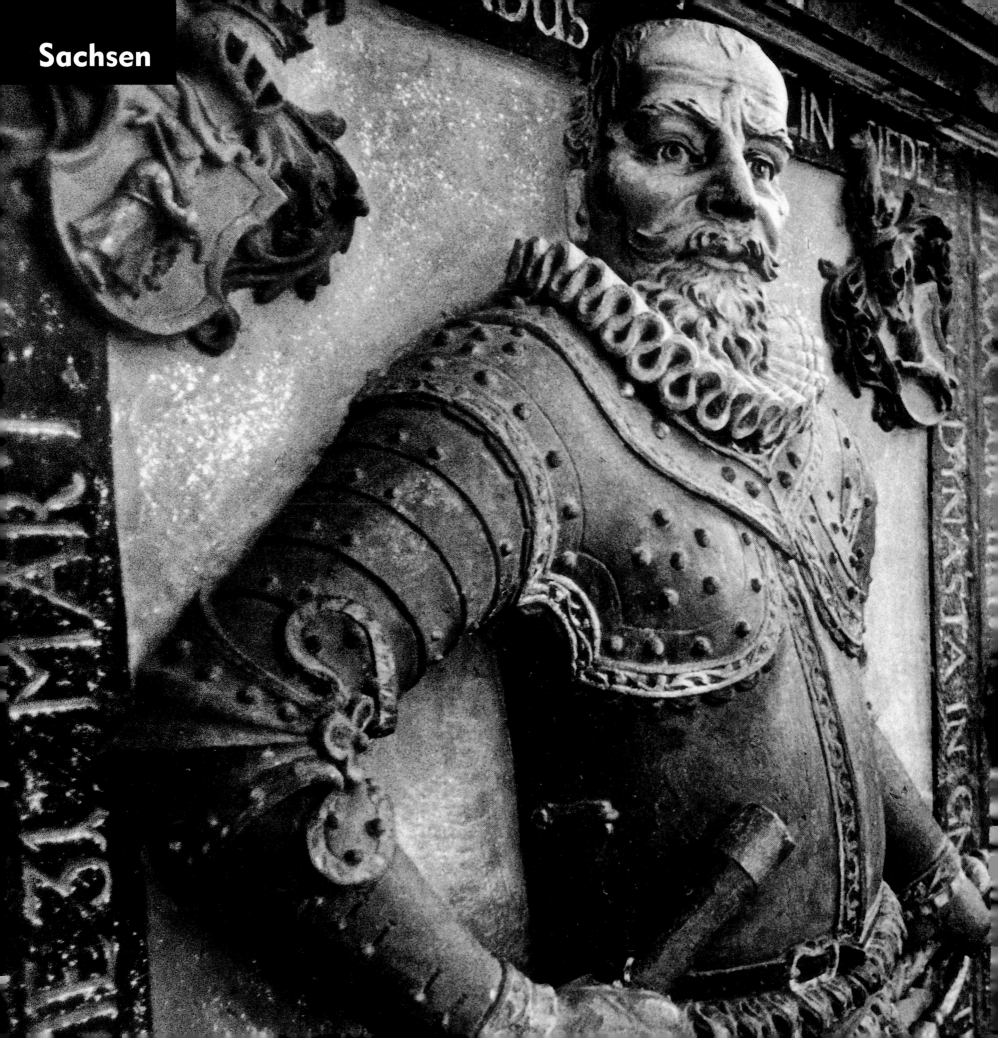

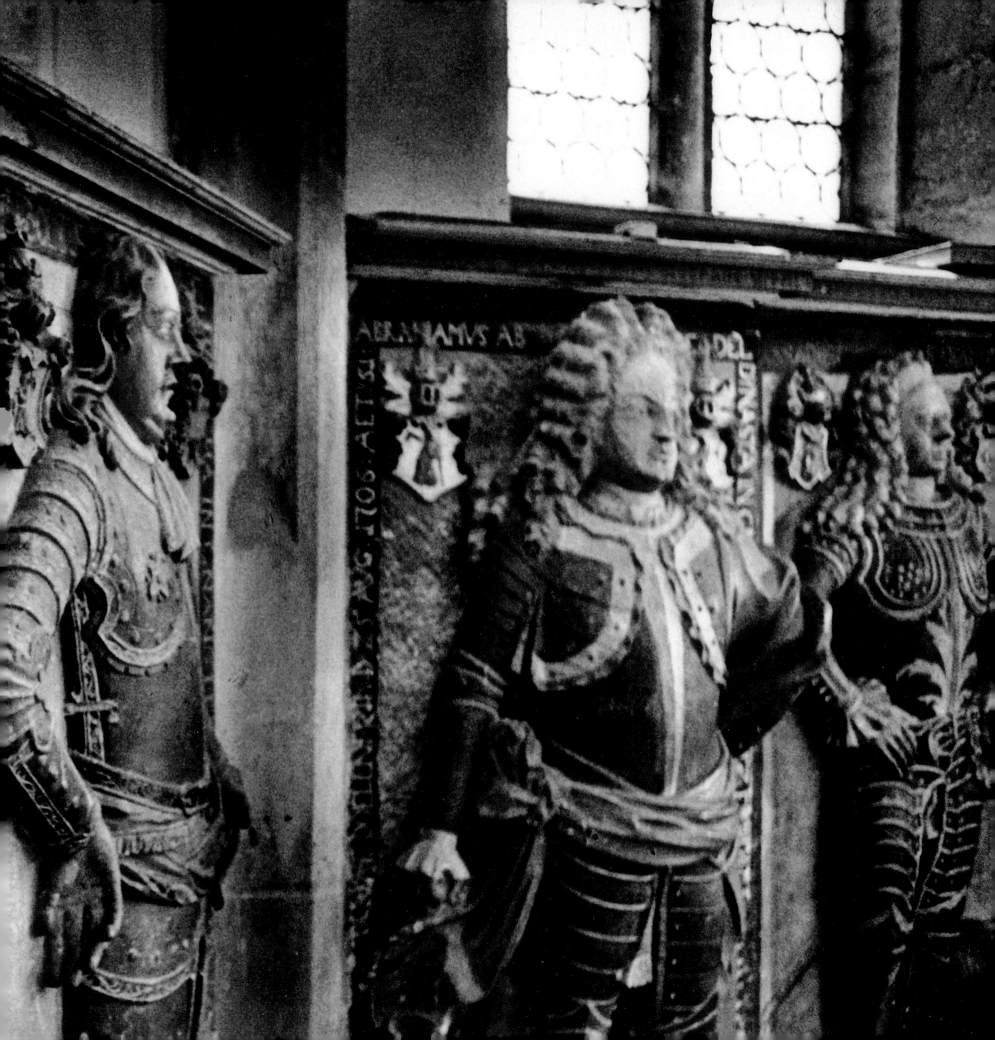

Burg Rochlitz

The next weeks and months remained calm. On 15 October 1945 we were told that all the owners of estates measuring more than 100 hectares and their families had to go to Schloss Colditz. We were only allowed to take furniture for one room. Schloss Colditz had been turned into a prison, and we had to report there before 16.00 hours on the named day. This came as a great shock to us. My estate measured 104 hectares and was therefore only marginally larger than the required 100 hectares. We had always believed that this was the reason for our sheltered lives so far. During the night we were personally told by the mayor, who had gone to the district magistrate's office, that our estate was included in the agrarian reform. He advised us to leave the house and to seek shelter in the village. The decision was a very hard one. Still, the next morning we left our estate, which had belonged to our family since 1821, only taking a backpack with us. We keep on praying that this is not the final decision, and that one day our German Fatherland will be joined together again.

Weissbuch **Nr 106 (B.F.)**

Opposite:
The castle lies in the beautiful Mulde Valley not far from Schloss Colditz, the notorious prison camp for officers during the Second World War. Part of Rochlitz, including the dungeons, dates from 1009, when it was occupied by Markgraf von Meissen. In 1852 it was turned into a three-storey prison and gained a sinister reputation, especially during Hitler's reign of terror. The cells were demolished in 1991.

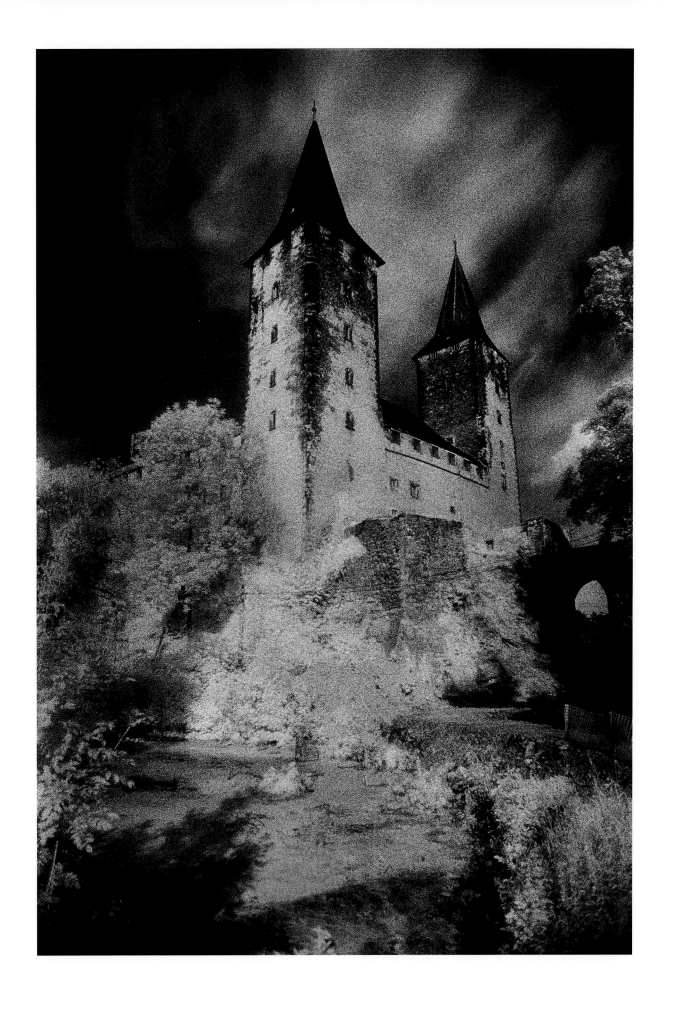

Nikolaikirche Cemetery, Görlitz

And I saw a great sadness descend upon mankind. The best grew weary of their works. A doctrine appeared, accompanied by a faith: 'All is empty, all is the same, all has been!' Indeed we have harvested: but why did all our fruit turn rotten and brown? What fell down from the evil moon last night? In vain was all our work; our wine has turned to poison; an evil eye has seared our fields and hearts. We have all become dry; and if fire should descend on us, we should turn to ashes; indeed, we have wearied the fire itself. All our wells have dried up; even the sea has withdrawn. All the soil would crack, but the depth refuses to devour. 'Alas, where is there still a sea in which one might drown?' thus are we wailing across shallow swamps. Verily, we have become too weary even to die. We are still waking and living on – in tombs.

Nietzsche
***Thus Spoke Zarathustra*:**
Second Part – The Soothsayer

Opposite:
The town of Görlitz, on the German–Polish border, became extremely prosperous during the fifteenth and sixteenth centuries, mainly through textile manufacture and trade in woad. This great wealth is reflected in the splendour of its Gothic, Renaissance and Baroque architecture. Even the Communist authorities recognised its importance, putting the entire town under a preservation order during their rule.

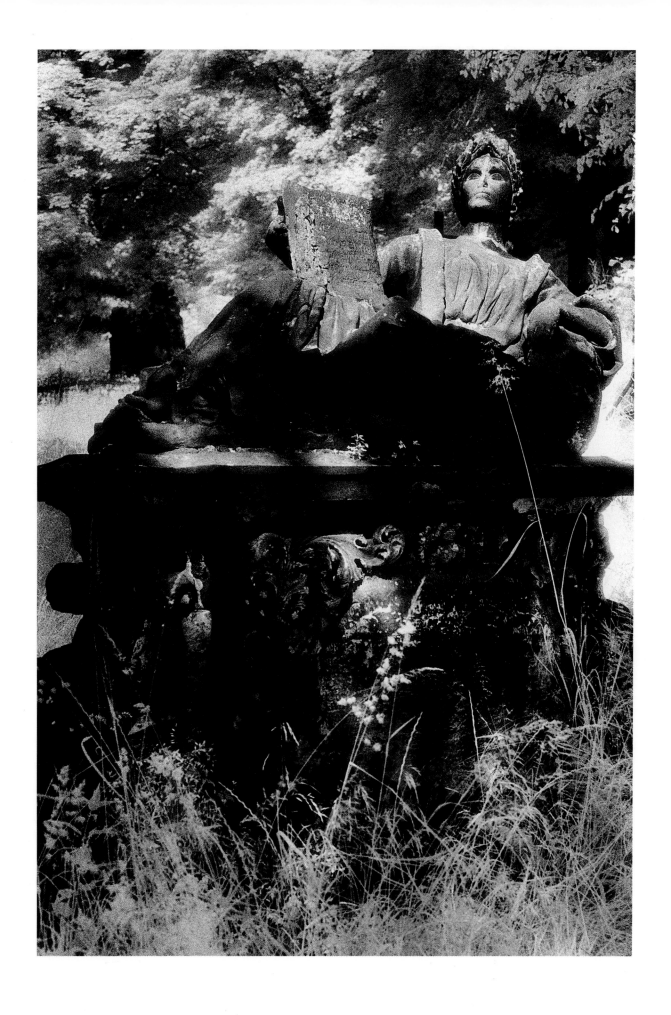

Barockgarten Gross-Sedlitz, Heidenau

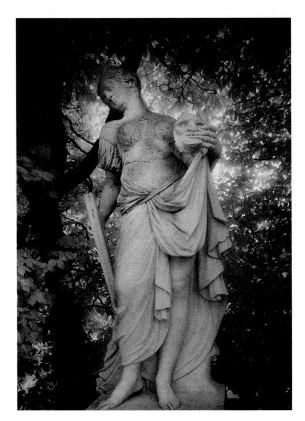

At 3 o'clock in the afternoon my wife and I, with eight close relatives (refugees) were loaded on to a closed truck and driven to the prison in Plauen. There were already hundreds of arrested estate owners camping in a big hall. We were registered by the new Communist district magistrate. Early the next morning we had to go to the station, from where we took a special train to Dresden. We spent the night in the central station in Dresden. On 24 October we were brought to Coswig, near Dresden, to the former Russian prison camp. This was a collection point for all the estate owners of Saxony. We stayed there under close supervision until 28 October. The previous day all our relatives were able to return home; only the owners and their wives and children had to remain in the camp.

***Weissbuch* Nr 108 (L.S.)**

Left:
A statue at Gross-Sedlitz

Opposite:
A sphinx at Gross-Sedlitz. The gardens were laid out in 1719 by Pöppelmann in the French style at the bequest of Count Wackerbarth, and completed in 1723 by August der Starke. This little known pleasure ground near Dresden is one of the greatest Baroque gardens in Europe.

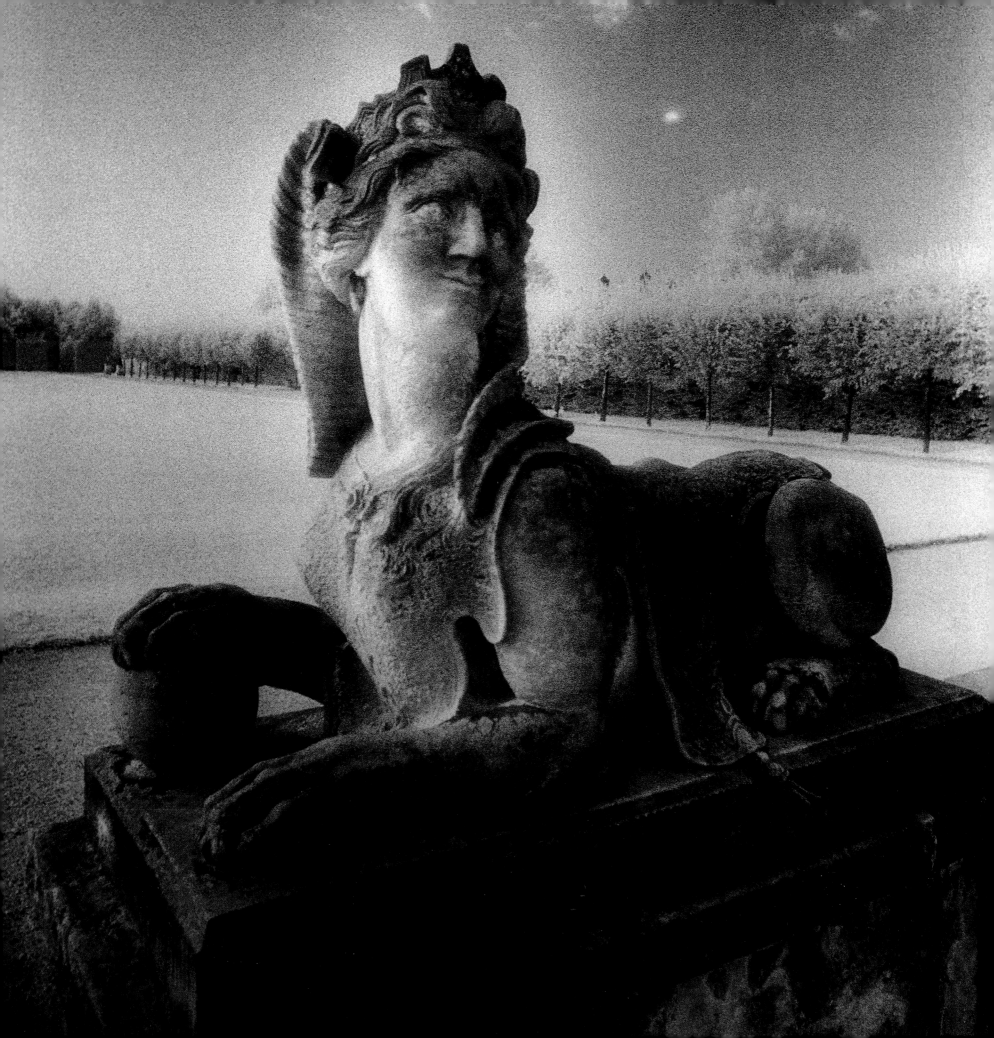

Alte Kirche, Wolkenburg

The day was warm. The beauty of the apple blossom on the trees was a wonder. The flowers, out in the hedgerows, the flies, bees and birds were everywhere in the spring haze. The little church high above the road we were on peeked out of the surrounding bushes and trees; we stopped and explored.

The graveyard around the church was well kept, unlike so many other churches, but inside was not so good and the chapel where the huge shield of Graf von Einsiedel lay was unkempt and derelict. The inscription read: 'He was a brave soldier who was killed in Battle at Kaiserslautern. Buried at Castle Frankenstein'. The heavy lead on the windows let little light through to give colour to his image. It was cold in the chapel. We left for the warmth outside.

Duncan H. McLaren

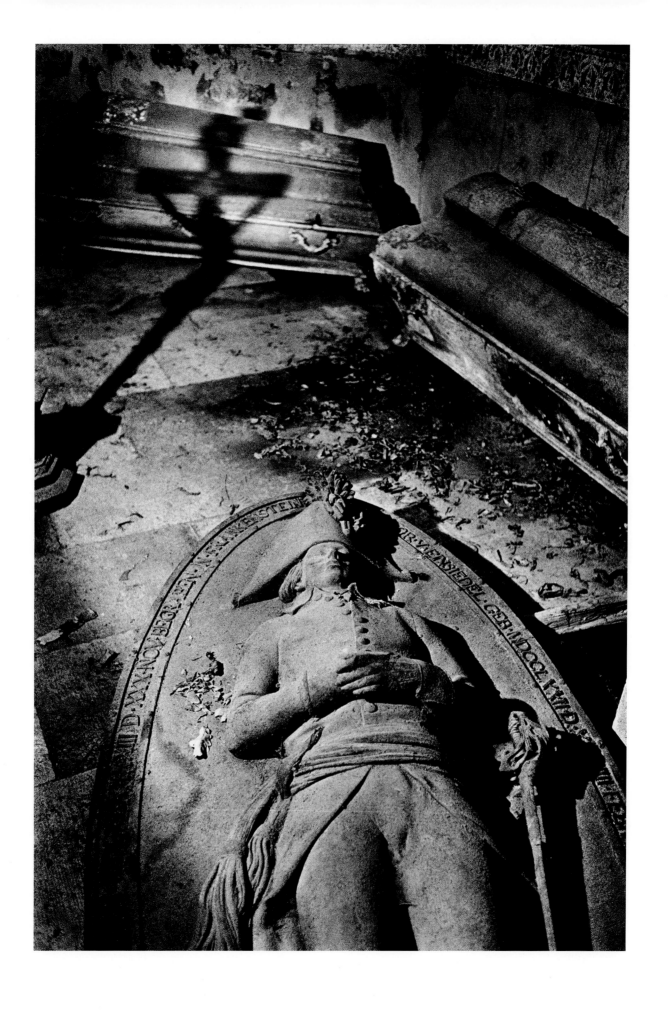

Burg Kriebstein

In my immediate surroundings the following happened.
The following were shot in C.:

Farmer W., in his flat, when he refused to give his watch to a Russian soldier.

Farmer Sch., who wanted to escape. He didn't hear the shouts of the Russian soldier since he was deaf.

Farmer K. in K., who wanted to escape as well.

Farmer H. in N., who was found in possession of a gun.

Mayor H., who had to hand over his car – which didn't start. Sabotage.

Inspector M. in G., after they had stabbed out both of his eyes and threw him on to the manure. He had been the liaison officer between the Wehrmacht and the agrarian division. His wife jumped out of a window.

Teacher M. in Sch., because he was wearing brown trousers and long boots.

The tenant W. in L. with six other farmers of the village, who had been herded together in revenge. Previously a car full of Russian officers had been shot at by people belonging to the Volkssturm at a tank blockade. They didn't belong to our village.

Farmer R. in L., with his wife, was beaten to death with spades, because one of his three Polish workers had said: 'Panje not good'.

The tenant B. in B., because the Russians didn't find any spirits in his distillery. Sabotage.

Weissbuch **Nr 111 (L.O.)**

Opposite:
The von Arnim family occupied Burg Kriebstein for 120 years before their expropriation in 1945. The castle, precariously perched on a high rock above a river, survives as a symbol of perpetual ascendancy in an ever-changing world.

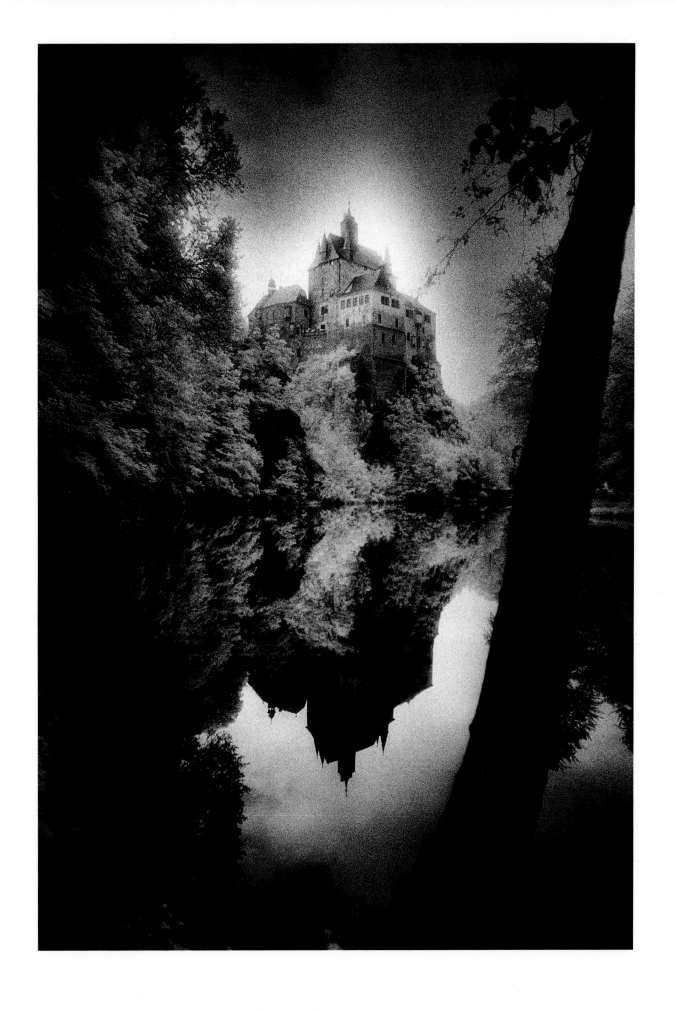

Schloss Nischwitz

Simon and I walked from the schloss into the park that stretched away between the trees and large eighteenth-century urns still on their tall bases. To the left in a group of dark trees was a small Palladian building. At first I thought it a summer pavilion, but it turned out to be a family vault. The Roman-style door opened when we tried it and we passed through into the gloom. The stained glass from the small cross windows had been smashed, as had the white marble sarcophagi on either side of a central passage leading to another tomb. Everything had been broken – the marble lay in pieces, the iron inlaid lettering had fallen out of its sockets – and the floor was covered with a dry carpet of leaves and mushrooms of an irregular kind. I reached down and picked one up. It was hard and did not crumble into dust. I looked again – it was bone, a joint. We were surrounded by bones, brown with age and exposure.

I replaced the bone and withdrew. There was nothing to say. Sadness was everywhere: in this place, on the floor, in ourselves. We left and ambled through the long grass. I walked alone along unkempt alleys of trees, where statuary still remained at vantage points to remind one that this had once been a very civilised place in which to stroll.

The schloss loomed large with its high and imposing roof, the ground floor almost lost to view by the tall grasses – I was that far away. It is now an old people's home, so at least it still has a roof. I crushed some leaves in my hand, and looked hard into the haze to the family past.

Duncan H. McLaren

Opposite:
'Point de Vue', Schloss Nischwitz. The mansion was the home of the von Ritzenburg family from the early part of the nineteenth century.

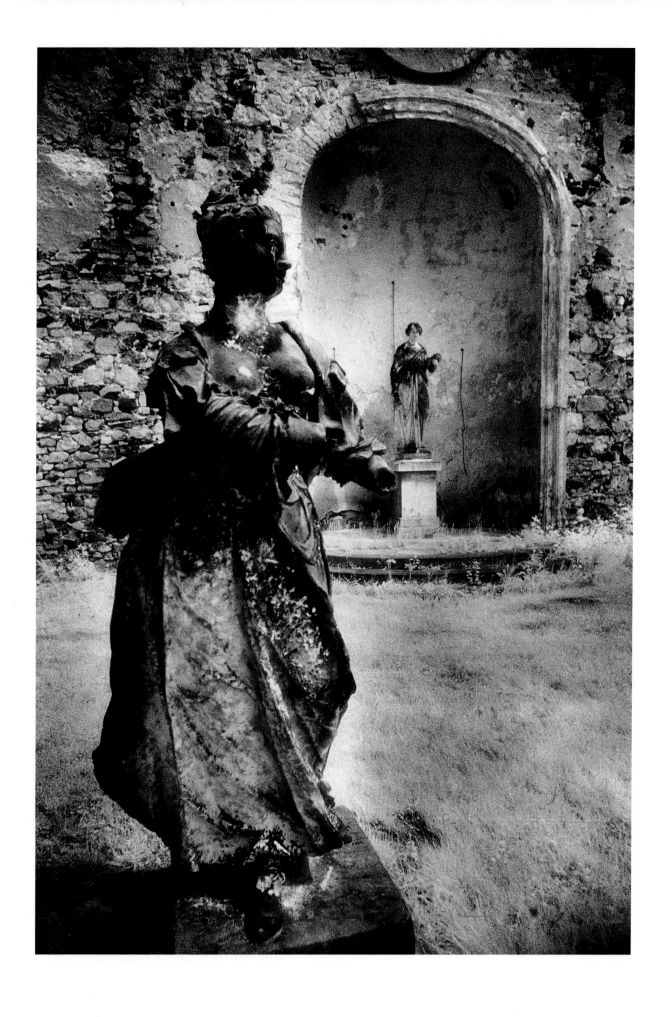

Dorfkirche, Gnandstein

My estate N. had suffered quite severely during the fights around Bautzen. The castle, with all its furniture and collections, had burned down on 20 May. The shepherd had been murdered. After my release from the Wehrmacht, in the American-occupied sector, I was employed as a ranger in West Saxony. After these parts were occupied by the Russians in the summer, I returned to N., which was completely ruined. I was handed a note from the Communist mayor, which told me that I had been expropriated. I never received an official notification. Since I feared being arrested, I left N. after two days. I have not returned since. My neighbour, Dr O., was killed during the Russian occupation. All my other neighbours were deported to the island of Rügen. I was spared this fate, since I had lost my home to the flames and was working as a ranger in Glauchau. I continued to work there until the expropriation wave hit there too and my management became senseless. I fled to the West. I never received an eviction order, because I had fled already, on 4 October.

Weissbuch **Nr 110 (Dr. v.V-R)**

Opposite:
Inside the beautiful church of Gnandstein stand several magnificent marble effigies, dating from the fifteenth to the eighteenth centuries, of the von Einsiedel family, one of the most distinguished noble families of Saxony (Sachsen). Their massive castle still survives on a rocky plateau above the village, a lasting symbol of their power and influence in this region.

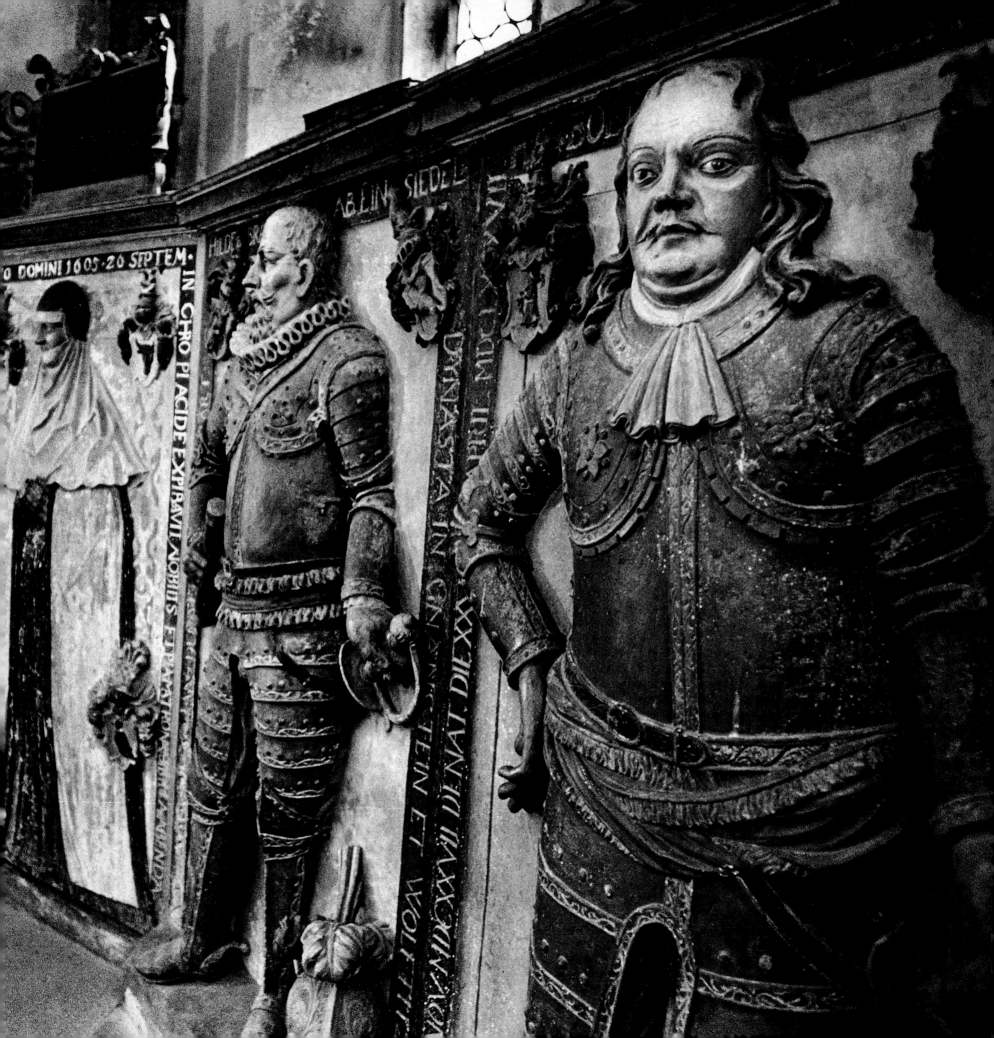

Schloss Bad Muskau

The small spa town of Bad Muskau is famous for its Schlosspark, the largest classical nineteenth-century landscape park ever made, now divided by the German–Polish frontier. This was the life's work of Prince Hermann von Pückler-Muskau, one of Germany's greatest landscape designers and travellers. For him landscaping was an art, but his grandiose dreams bankrupted him and he was forced to sell the estate in 1846 to Prince Frederick of the Netherlands, who re-built the schloss in the Renaissance style. Having somehow survived the ravages of the Second World War, the fantastic ruins stand today amidst the romantic grounds.

As an unconventional young man, Pückler-Muskau shocked his contemporaries by entering his family's burial vault at midnight to force open his ancestors' coffins, and later held a banquet using their shrouds as tablecloths. He endured a loveless but harmonious marriage, finding brief happiness with a young Abyssinian slave girl named Machbuba whom he brought back to the schloss from one of his trips to the Orient. She died shortly afterwards and he was said to have been overwhelmed by grief. In his old age he became increasingly eccentric, some say finally insane, and took to driving around his magnificent park in a resplendent, ornate carriage pulled by twelve white deer. When he had to leave Muskau under threat of seizure in 1846, he took up a new project, Branitzer Park in Cottbus (see page 104), on which he worked until his death in 1871.

Simon Marsden

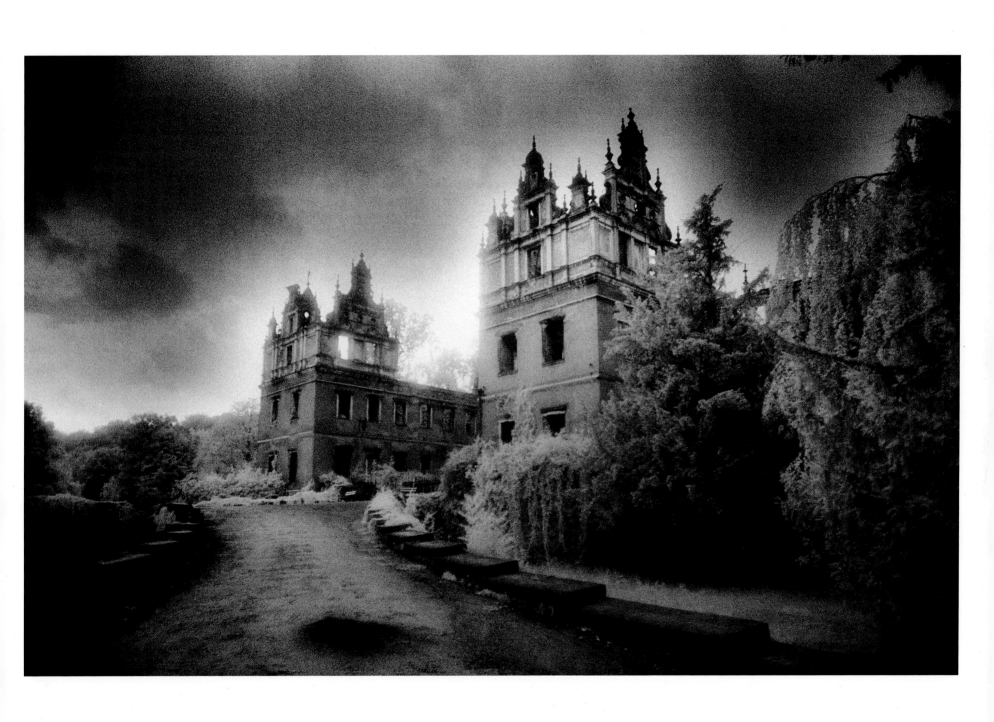

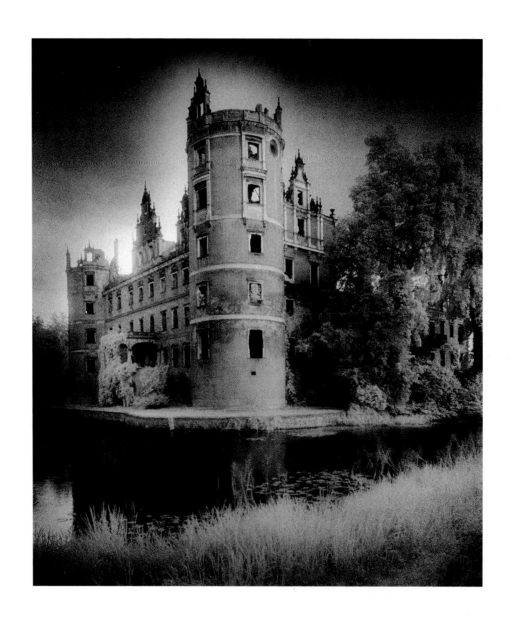

Opposite:
Among the weeds and wild flowers of the overgrown village churchyard lies Machbuba's small tomb, which bears a photograph of the unfortunate girl. The protective glass is shattered, the picture torn and covered with dead flies. A wax model of her stood in the gardens of the schloss until it wasted away.

Dom, Freiberg

In the summer of 1985, I went on holiday with a great friend, Heinrich Spreti. We drove to the border lands, and queued to pass into the East. We went to see his aunt's house near Karlsbad. The schloss was called Dallwitz, and the family's name was Riedl von Riedenstein. It was this visit that led to this book with Simon. Then it was impossible because permission to travel freely would never be given. I thought perhaps one day …

The forgotten house was boarded up and forlorn with barbed wire right up to the walls. We walked along the village street to the cemetery and found the family grave. Where all around was overgrown, a tangle of brambles and nettles, their grave was beautifully kept – a patch of sunshine in dark surrounds.

As we returned through the village, a very old lady asked Heinrich if he was a relative. When he said he was, she wept. She said she knew one day that someone would come back. Before fleeing the Russians, the Gräfin had given her money and asked her to tend the family grave. Forty years had passed since then and she had lost her own family during the war. We gave her all the money in our pockets. This was four years before the Wall came down.

Duncan H. McLaren

Opposite:
A statue at the Dom in Freiberg. The richness and variety of the interior decoration of the cathedral is unsurpassed in Germany. The town lies in a once prosperous mining community and the Gothic building was constructed between 1484 and 1501 as a result of this wealth. Its mining traditions endeared the town to the Communist authorities.

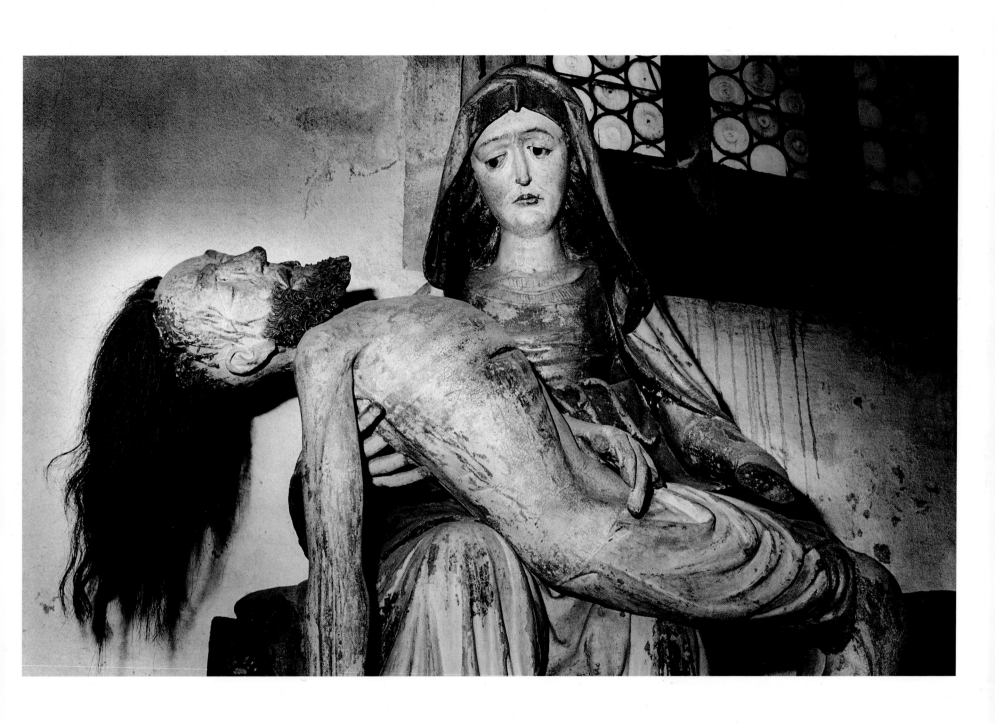

Burg Stolpen

In 1813, during the Napoleonic Wars, the castle was sacked by French, Austrian and Russian troops, but the great towers still stand above the surrounding landscape as symbols of enduring power. Originally the residence of the Bishops of Meissen in the thirteenth century, the building was later used as a state prison and became the property of the Princes of Saxony in 1559.

Whilst climbing the stone steps of one of these towers, I recalled that the fortress's most celebrated captive had been Anna Constance von Brockdorf, Countess of Cosel. She was the mistress of August der Starke, or 'August the Strong' (1670–1733), who was responsible for the Baroque heritage of Dresden during his turbulent reign as ruler of Saxony and King of Poland. He was said to have possessed phenomenal strength and sexual prowess, numbering amongst his many lovers the abbess of the imperial convent in Quedlinburg.

August became infatuated with Anna, promising that one day she would become his queen. She, in turn, tried to influence his political thinking, especially regarding the throne of Poland, through her many charms and, as some of his courtiers later claimed, witchcraft. August, an ambitious, ruthless dictator, began to realise that this relationship was undermining his power and plotted her downfall.

The Countess was thirty-six years old when she arrived at Stolpen, where she was held a prisoner without trial for almost fifty years, until her death in 1765, aged eighty-five. Other records claim that after twenty-eight years she was set free, but chose to spend the rest of her years in the castle she had come to love as much as her wayward king.

Simon Marsden

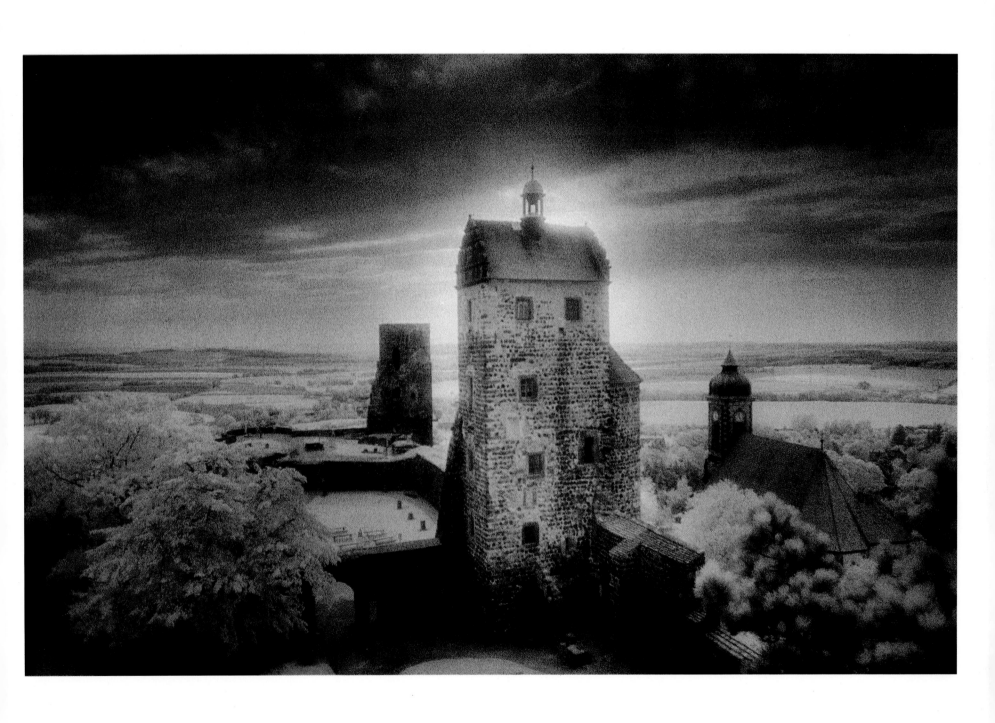

Schloss Hainewalde

The graveyard is overshadowed by the dramatic eighteenth-century mausoleum of the Kanitz-Kyausche family, former owners of the now wrecked schloss. Macabre allegorical statues stare down from their weathered niches, defying intruders to enter the heavy, locked door.

The adjacent church is being restored and there we began talking with two local workmen. They told us about their lives under the Communist regime and how they had longed for their freedom, but now they felt insecure that their jobs were no longer guaranteed in a capitalist society. They then offered to show us inside the mausoleum. As the ancient key turned in the lock, my imagination conjured up all manner of bizarre images that might confront us. Sadly, we were disappointed. A tall, plain wooden cross stood in the middle of the room, dominating the space. Obscured by this modern-day impostor was a much older monument to the Kanitz-Kyausche family. The workmen explained that this mundane cross had been placed there by the local Communist council to 'offset the grandeur and decadence of such ornate effigies'.

Simon Marsden

Left:
A sculpted head above a
doorway, Schloss Hainewalde

Opposite:
The Kanitz-Kyausche
mausoleum

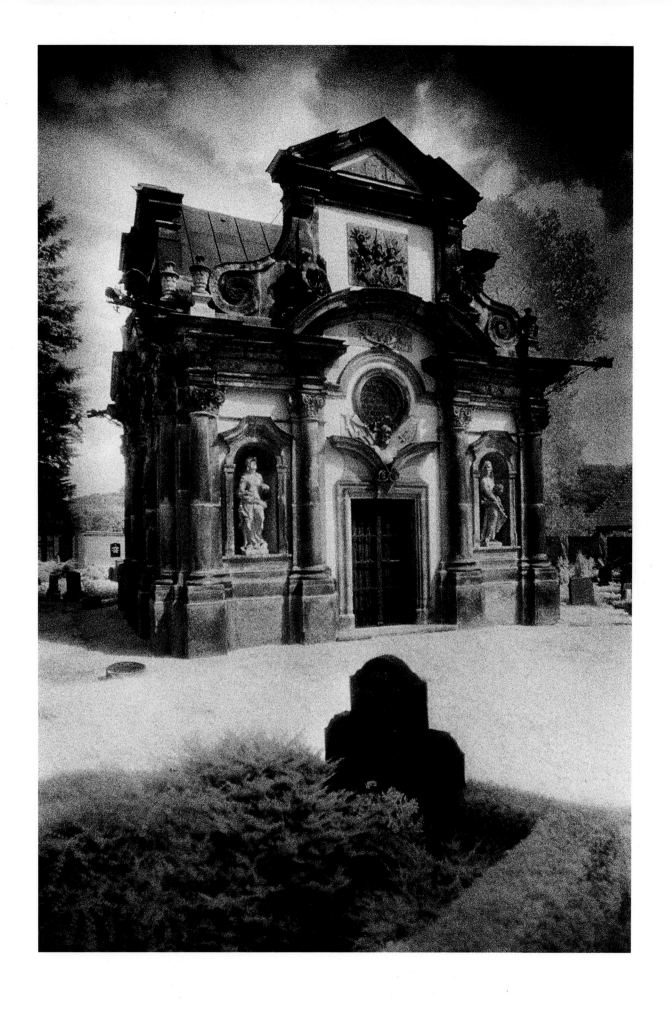

Schloss Hartenfels, Torgau

I was in church with my wife on 30 September 1945, the day of thanksgiving. During Mass my ten-year-old son suddenly appeared next to me and told me that the police were waiting outside the church. I was to come out immediately. One policeman told me that I had to appear at a hearing and to bring a blanket and enough food for three days. A bus was parked outside my estate, containing most of the estate owners whose lands measured more than 100 hectares. We were escorted to the Phönix tile factory near Meuselwitz, where we were meant to spend the night. We remained there for eight weeks. Nobody had organised our food supply, but some local farmers brought offerings. On the third day our wives and children joined us there. They were released after twenty-four hours, with the obligation to keep a distance of 15 kilometres from our former homes. After a stay of eight weeks, we were to be taken to the island of Rügen. Most managed to avoid the deportation by escaping. I had been told of my expropriation in the camp, where a guard informed us: 'You will never be able to return to your estates.'

Weissbuch Nr 136 (H.S.)

Left:
A gargoyle, the 'Grosse Wendelstein'

Opposite:
Gargoyle and sculpture, the 'Grosse Wendelstein'. This ornate spiral staircase by Conrad Krebs dominates the courtyard of the large Renaissance palace, which is entered by crossing a bridge above a bear pit. There is a memorial in Torgau commemorating the fact that it was here, in the closing days of the Second World War, that the advancing armies of the Soviet Union and America finally met up.

Overleaf:
The entrance to the Neues Palais, Potsdam

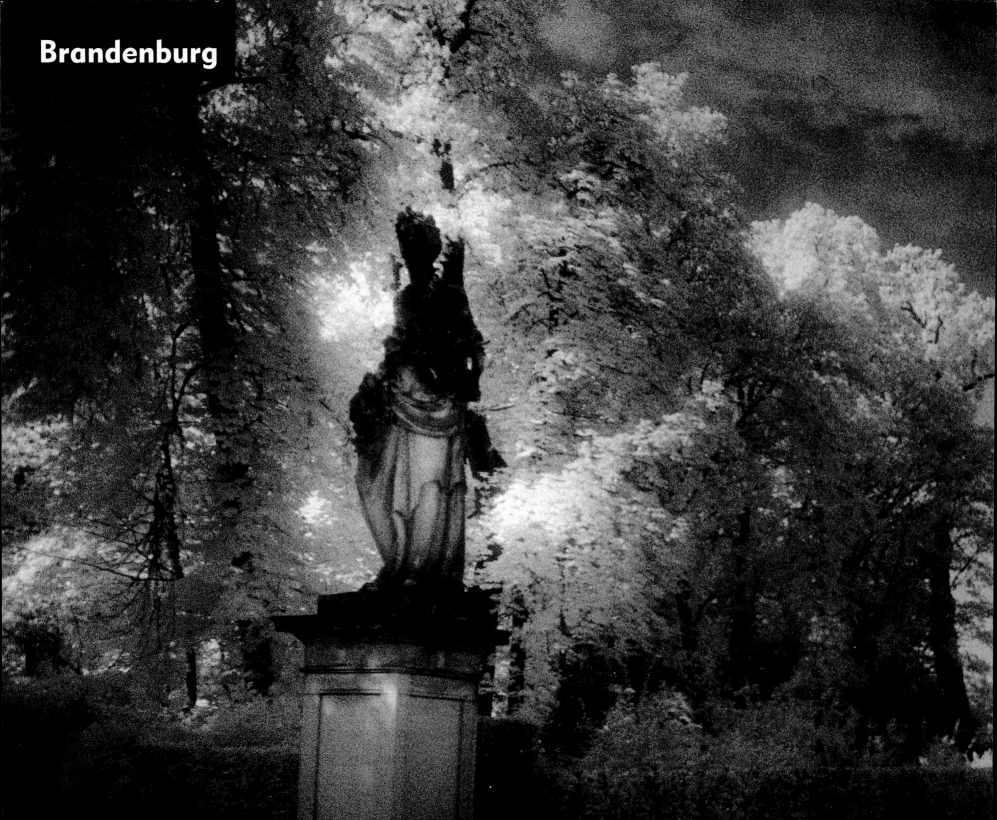

Brandenburg

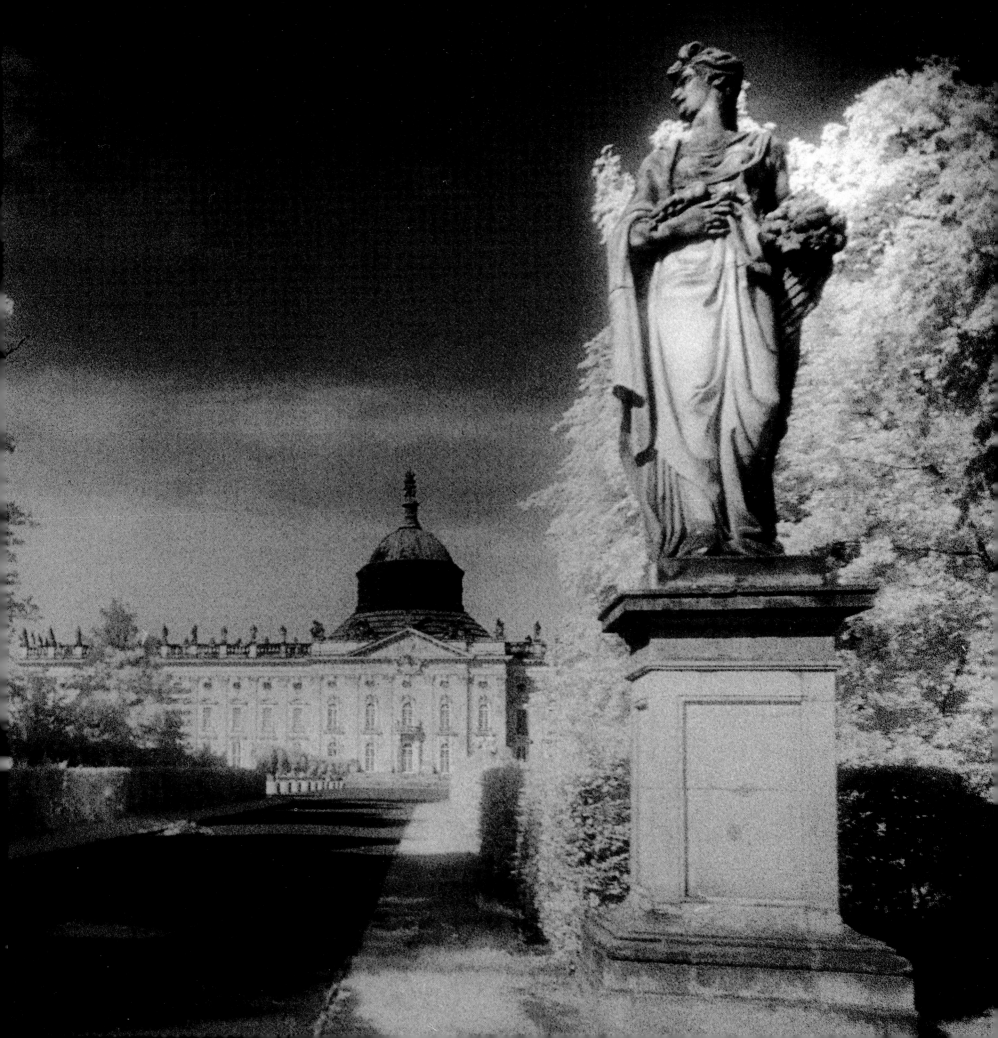

Schloss Gusow

We found the once famous park and gardens at Gusow little more than a jungle of tangled undergrowth, the flowerbeds and lawns no longer recognisable, their statuary smashed or stolen. In the fifteenth century the estate had been owned by the von Schapelow family, who became a powerful influence in the surrounding area. Their meteoric rise was followed by an equally sensational fall, and by the middle of the seventeenth century they had lost everything. Maximilian Wilhelm von Schapelow was only able to enjoy his property for one year before he was murdered by an untrustworthy servant near Zerbst. Because his male heirs were so young the estate passed, through the marriage of one of his daughters, to a General Georg von Derfflinger in 1646, and later to the Counts of Podelwitz in the eighteenth century. It was during these two periods that the magnificent gardens and parkland were created. They were greatly admired by the romantic Prussian king, Friedrich Wilhelm IV, who designed the Friedenskirche or 'Church of Peace' at Potsdam in 1845 and who was a frequent visitor here, where his ancestors had often hunted.

Since 1805 the aristocratic line of Schönburg-Waldenburger owned Gusow, but the family was forced to flee at the end of the Second World War when the estate was expropriated by the Russians. The valuable library and the rest of the castle's contents had been either destroyed or stolen by 1950 and the beautiful grounds went into steady decline. The mansion was used in turn for corn and fertiliser storage, a recuperation camp, a youth club and an industrial kitchen. The Communists had no funds for renovation and no wish to restore such a symbol of the hated 'estate owning class'. The dream of kings had ended.

Simon Marsden

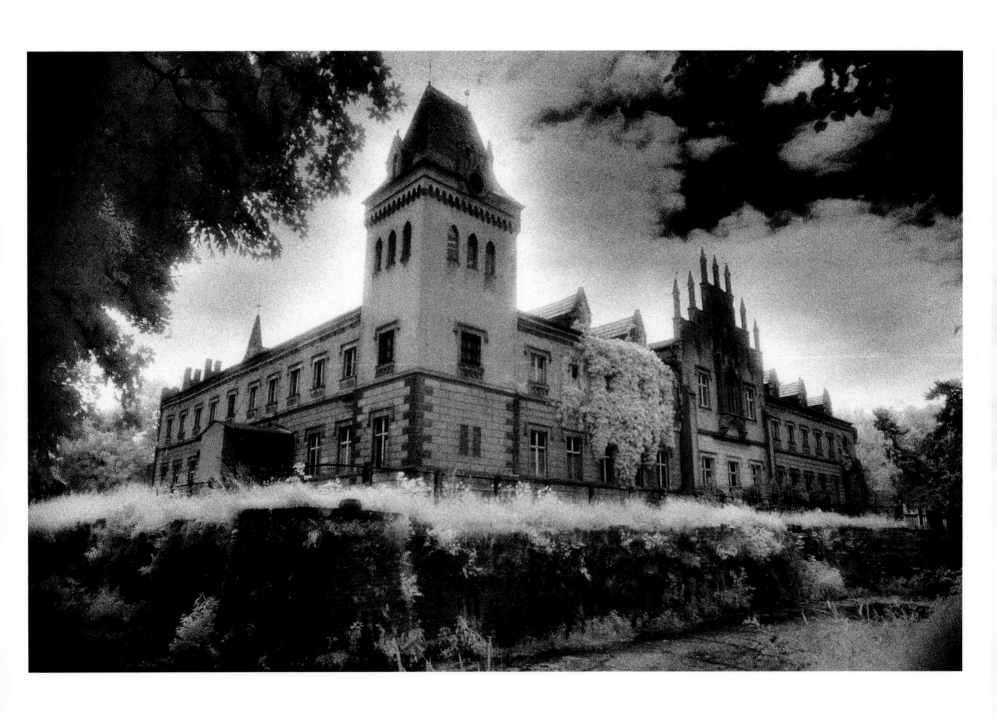

Kloster Neuzelle

It is hard to describe all the murders, plunders and rapes of women and children, aged between twelve and seventy years, which took place day and night in the months after the Russian occupation. The farmer M. of W. was shot by the Russians outside his front door on 2 June 1945 because he didn't want to tell them where the girls were hiding. His fate was shared by the estate owner, J.D. The owner of the knightly manor v.A.R., who had returned from the escape to manage his estate, decided to poison himself and his wife because he saw no other alternative. At the beginning of June 1945, I was asked by the Communist district magistrate of Prenzlau to return to my estate, as the manager, in order to bring in the harvest.

When I returned to my estate with my son, on 20 June 1945, we were arrested by a Russian officer and were locked into a cellar of the house, because they had found hidden hunting rifles. I was able to prove, through witnesses and engraved names, that they did not belong to me. The death sentence against myself and my fifteen-year-old son was later lifted by General Schukow. During the days of imprisonment, we had to dig our own graves in the back garden. We were regularly placed against a wall and fired at, although they aimed above our heads. We were herded around the garden at gunpoint to show them where we had buried our gold and silver. We were abused. After the sentence had been lifted, we brought in the harvest until 15 September 1945. On this day I was arrested with my family and brought to the prison in Prenzlau in order not to disturb the agrarian reform. We were released from prison on 20 September 1945 with the order not to return to our estate and to leave a 25-kilometre radius around it; this was later changed to 50 kilometres. The expropriation document was a piece of paper without a signature or stamp.

Weissbuch **Nr 41 (N.-D.)**

Opposite and left:
The magnificent Gothic chapel of the Cistercian monastery at Neuzelle was built in the thirteenth century. The rich Baroque interiors are a jewel in Brandenburg's crown.

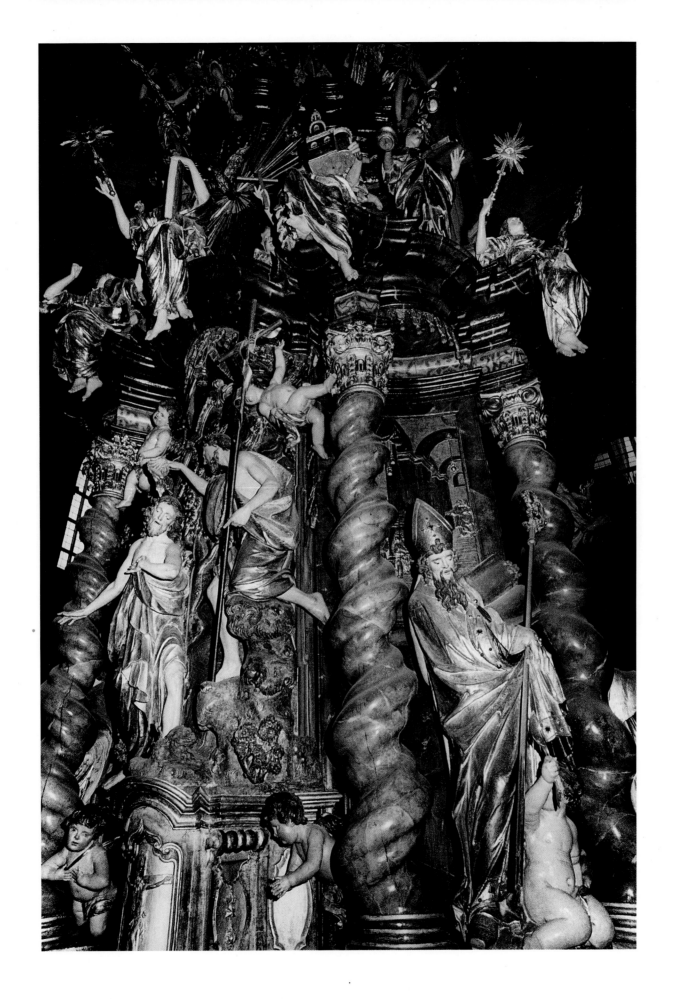

Schloss Branitz and Branitzer Park, Cottbus

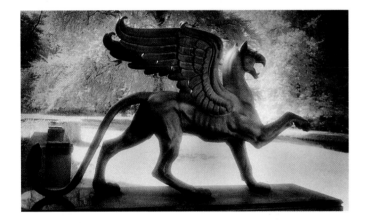

After the forced sale of the Schlosspark at Bad Muskau in 1846 (see page 86) Prince Pückler-Muskau invested the proceeds in Schloss Branitz, where he dedicated the rest of his life to re-designing and improving the landscape. As eccentric in death as in life, he had a pyramid constructed in one of the lakes to contain his grave. It is inscribed with the words: 'Graves are the mountains of a distant new world'. The pyramid bursts into flame in early autumn when the wild vines covering it turn scarlet and crimson.

Simon Marsden

Left:
A bronze griffin on the terrace at Schloss Branitz

Opposite:
Prince Pückler-Muskau's tomb. The schloss was built by Graf August Heinrich von Pückler in 1772 and remained in the family until its expropriation in 1945.

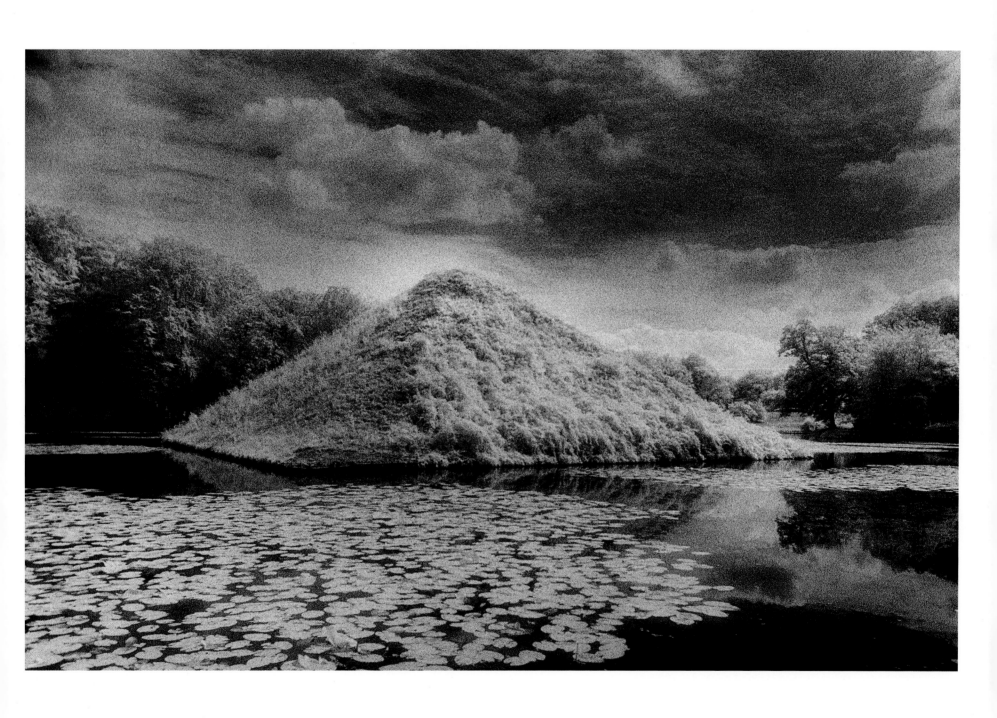

Schlosskapelle Lindenau

Shortly after the Russian occupation, my husband was shot by drunken Russians without reason. We had to endure the ravings of soldiers in the house of the administrator. Nearly all the women were raped. These animals raped women and children alike; even my nine-year-old daughter was raped by them. Out of sheer desperation hundreds committed suicide. Our itinerant workers, Russians, Poles and Italians, were kind to us and tried to protect us from their 'liberators'. Our yard was immediately managed by one of our Communist gamekeepers, who spoke Russian.

At the beginning of October 1945 I was told by the mayor and a gentleman from the district administration that I was expropriated. A week later, we had to leave the house and yard. We moved to Kreisstadt with a couple of pieces of furniture.
We were not deported. When we were extradited from the district on 8 September 1947 (S.M.A. Order Nr 6080 of 28 August 1947), we were only told that we could move to Oranienburg (concentration camp). We went west, this time taking only our hand luggage.

Weissbuch Nr 31 (Mrs J.R.)

Opposite:
An early eighteenth-century funeral monument to Gottlob Ehrenreich von Minckwitz. On his left sits a representation of the 'Angel of Death'. The family chapel was built by Loth Gotthardt von Minckwitz in 1668.

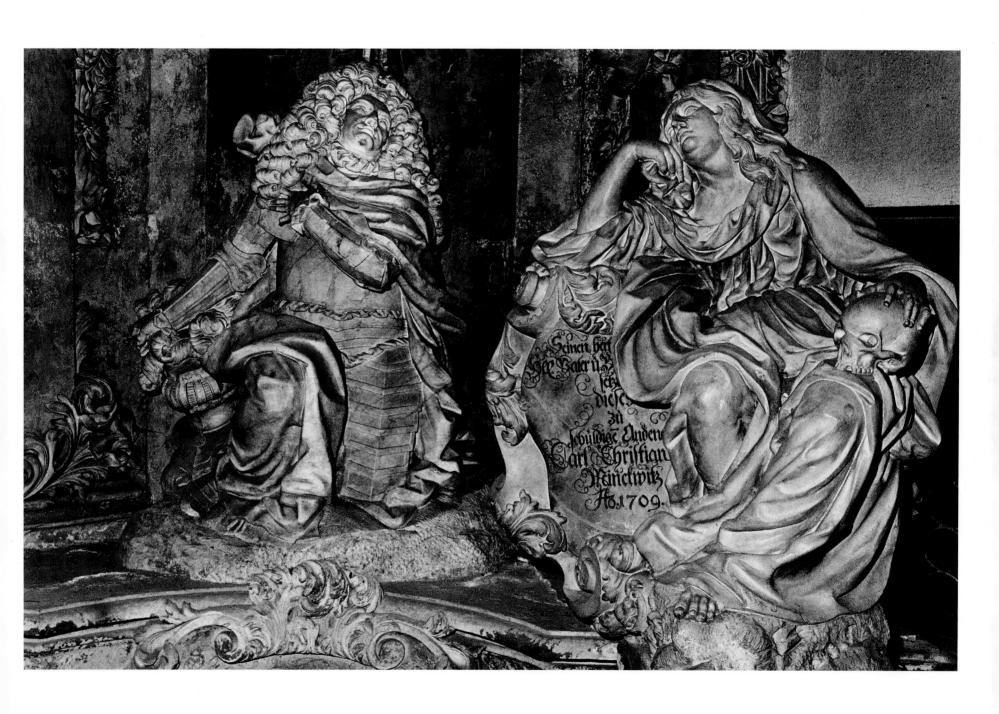

Potsdam

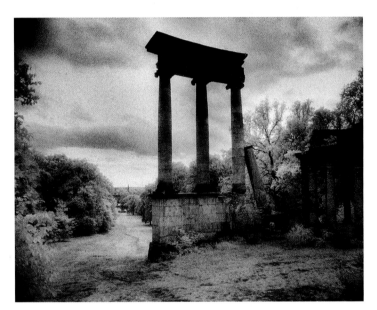

Frederick the Great (1740–1786) suffered an unhappy childhood at the hands of his austere father, Friedrich Wilhelm I, the Prussian 'Soldier King', who frequently thrashed him and forced him to kiss his boots in public. In later years Frederick tried to flee the country with his friend Hans Hermann von Katte, with whom he had a very close relationship, but they were betrayed and Katte was executed on the King's orders.

Frederick's accession to the throne on his father's death in 1740 brought with it a more liberal regime. A great patron of the arts and music, he was also a man of letters. Fantasy and imagination were to be the themes that would shape his residence in Potsdam, where he began to build a Rococo palace on a hill overlooking the town. Here he wished to live 'without cares' – '*sans souci*'.

A francophile to the point of near mania, Frederick's eight great libraries were full of seventeenth- and eighteenth-century French literature, and one of his most celebrated house guests was the French philosopher Voltaire, who lived here from 1750 to 1753, acting as a private tutor to the King. Frederick believed that his own countrymen were philistines incapable of producing great art. It was said that he would 'rather a horse sang him an aria than allow a German in his opera'.

Simon Marsden

❝ **Architecture is frozen music** ❞
Friedrich von Schelling

Left:
The Ruinenberg Folly, Sanssouci Park. These artificial classical ruins lie on a hill north of Sanssouci Palace.

Opposite:
A sphinx by Ebenhech (1755) at the entrance to the Baroque vine terraces, Schloss Sanssouci. Frederick worked closely with the celebrated architect von Knobelsdorff when designing his fantasy palace between 1745 and 1747.

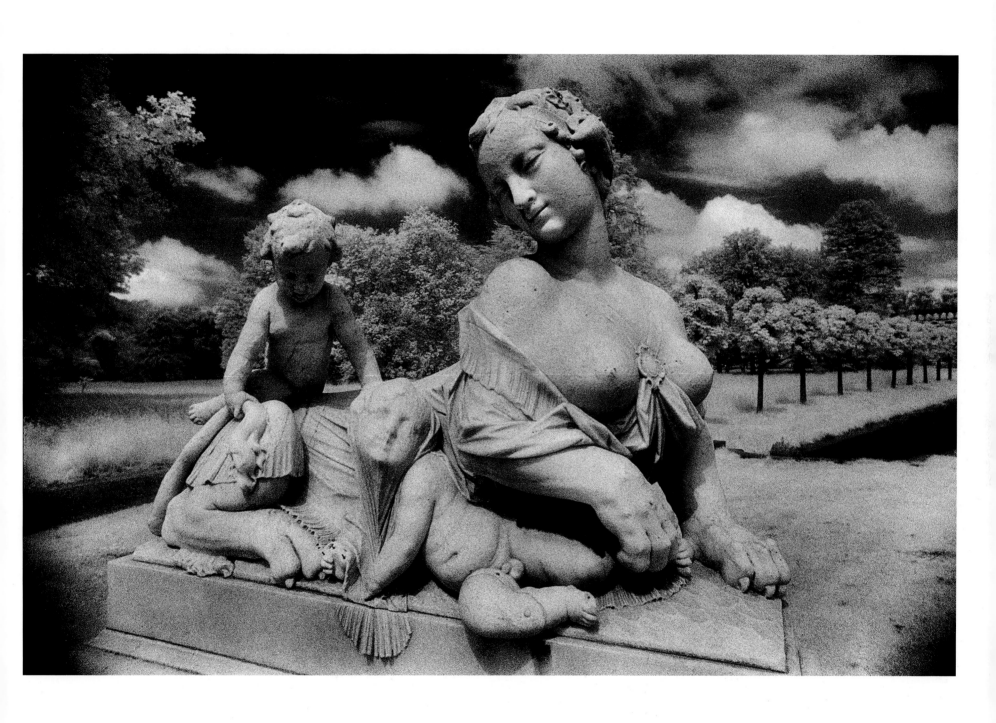

Potsdam

Twilight down from high has drifted,

What was near's already far;

First, though, high above is lifted

Graced in light the evening star!

All on imprecision verges,

To the heights the mists slow snake;

Darkness into blackness merges

Mirrored in the resting lake.

Goethe
Chinese-German Hours and Seasons
(1827–30) VIII

Hedges guarded the original views that lead to Frederick the Great's most magical Chinese pavilion. Paths wove their way through woodland, gardens of green trees and shaded coloured flowers. The wanderer would, as if by chance, pass an arch of leaves, or an opening in this greenest of walks, to be stunned by this summer house of gold.

It was built between 1755 and 1764 for the gardens of Sanssouci. The fashion then among the royal and noble families of Europe was for all things Chinese: vast blue and white vases, famille rose, celadon and turquoise, painted wallpapers, silks for hangings and treasures of gold, porcelain in miniature mirrors and lacquers for walls, panels and furniture transformed many a room in Vienna, Berlin and London. Here, this fantasy golden pavilion, the triumph of all that is Rococo, stands proud.

Duncan H. McLaren

The Chinesisches Teehaus –
the Chinese Teahouse,
Sanssouci Park

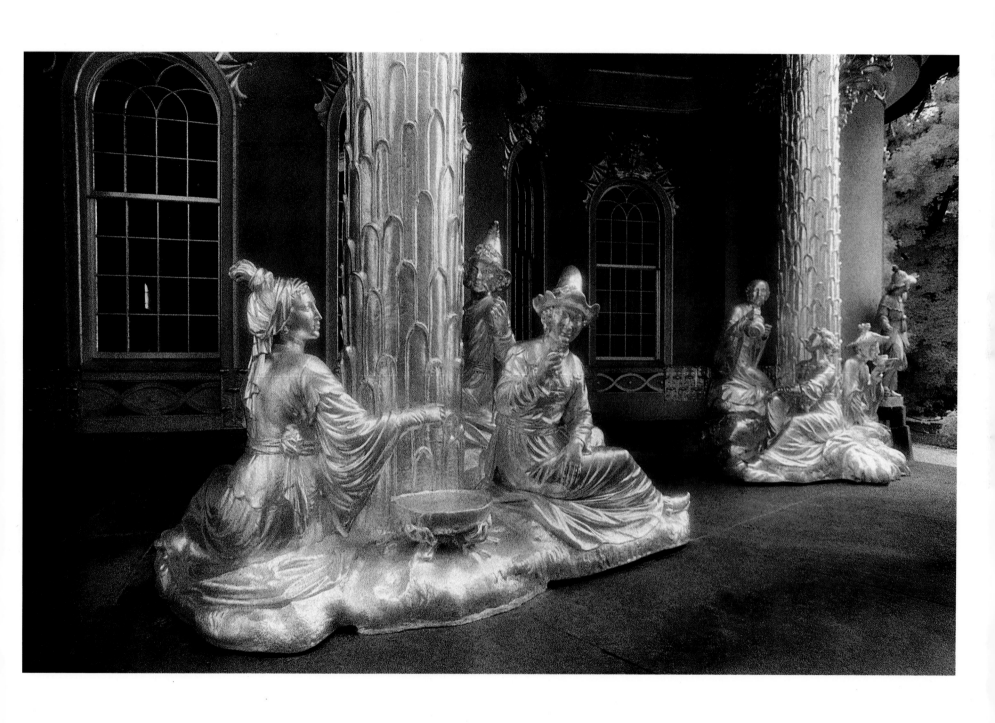

Potsdam

'Make your beds!' the mother commanded her two little daughters. 'We are leaving for a long journey!' There were no more servants in the castle. All of them had been summoned to join an official meeting of the National Socialist Party. The girls obeyed. They and their mother went downstairs and out into the courtyard. A coach was waiting to take them on a long trip – a trip with no return.

It was a very cold winter day. The party were allowed to take only small luggage, the clothes they stood up in, a leg of ham and the girls their beloved teddy bears called Prince Teddy and Prince Baerlein. The two little girls were princesses themselves, THRH Princess Felicitas, aged ten, and Princess Christa, aged eight, daughters of Prince Wilhelm von Preussen, the eldest son of the last German Crown Prince. The girls were great-granddaughters of Wilhelm II, the German Emperor, grandson of Queen Victoria.

The Soviet army was approaching fast to the German–Polish frontier. They were close to the Prussian royal castle. The German army was retreating, hounded by Soviets. You could hear shooting and the detonation of bombs. It was time to leave. The only way was to follow the Germans westward. It snowed constantly; the horses shivered. The girls jumped into the coach with their mother and grandmama. Just before the coachman closed the door, Tipsy, the beloved fox terrier, jumped on to their laps. Tipsy was used to accompanying the princesses when they went hunting; now all was changed – they were the hunted.

Opposite:
A fountain below the Ruinenberg Folly, Sanssouci Park. The greater part of the park was designed by Peter Joseph Lenné, the most talented landscape gardener in Prussia.

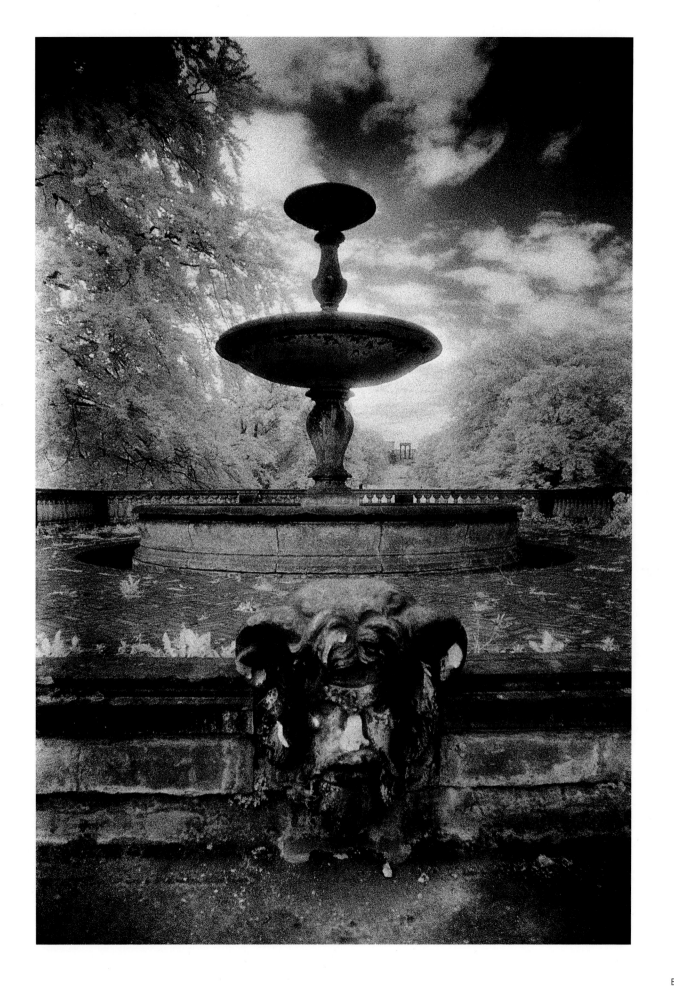

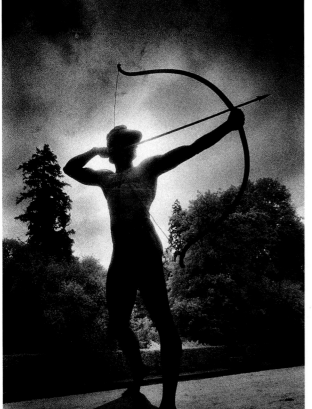

After a long journey the family finally reached another hunting lodge of the last Imperial family. There they spent the night waiting for a car to take them to Cecilienhof, the family residence in Potsdam.

The car arrived. It turned out to be too small for the whole party. The ADC of the Crown Prince, who had been sent to accompany the princesses and their mother, suggested leaving their maternal grandmother behind. Princess Wilhelm, Felicity's and Christa's mother, produced a pistol and shouted: 'Either you take my mother as well or I shall shoot all of us!' ADC Major von Müller was a typical Prussian soldier, tall and authoritative. He was shocked and looked frightened. He didn't dare to move. The princesses looked at each other and smiled, knowing that their mother was not able to use a pistol.

The ADC did not dare to refuse and the whole family left in the tiny car for Cecilienhof, their grandfather's residence – the building at Potsdam in which the division of the former German Reich was decided by the Allies some months later. Their arrival here was only the beginning of a long odyssey.

HRH Princess Christa von Preussen, a memory, 1999

Left:
This massive bronze archer by Geyger stands guard below the Orangerie. It was commissioned for Sanssouci Park by Wilhelm II in 1901.

Opposite:
Classical statues lined up for restoration in front of the Neues Palais

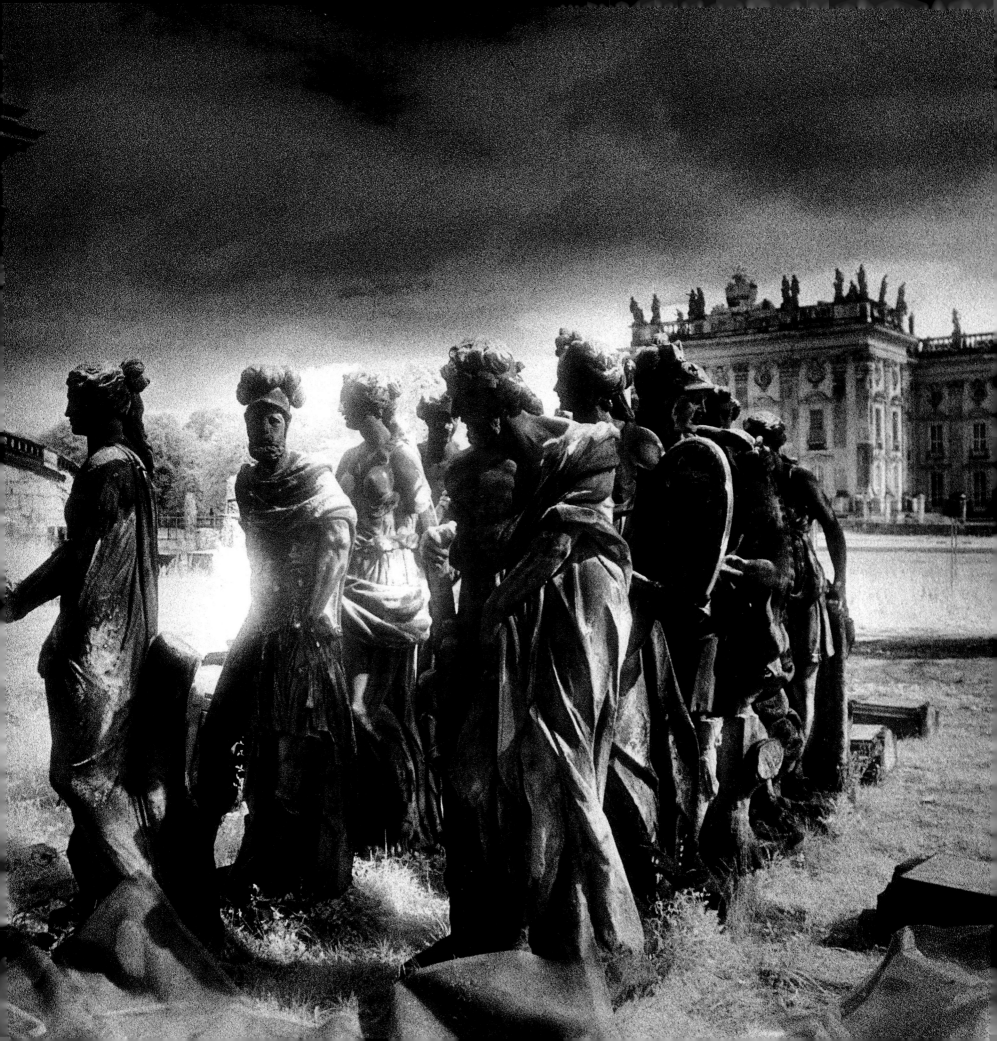

Potsdam

Frederick the Great built this unrestrained Baroque extravaganza between 1763 and 1769 to reaffirm the might of Prussia and her King after the Seven Years War.

At the centre of the palace is a huge green weathered dome, surmounted by a golden crown. The edges of the roof are lined with sculptures. The grandeur of the interior is unsurpassed and, of the four hundred rooms, the most bizarre is the Main Hall, or Grotto, where one is plunged into a fantasy of undersea architecture, created from semi-precious stones, crystals and pearl and peopled by strange sea creatures. There is a sense that the spectre of insanity haunts this chamber.

The last of his line to reside here, Kaiser Wilhelm II, built his own railway station, and it is said that he packed sixty railway carriages with the contents of the palace when he and his family left after his abdication in 1918.

Simon Marsden

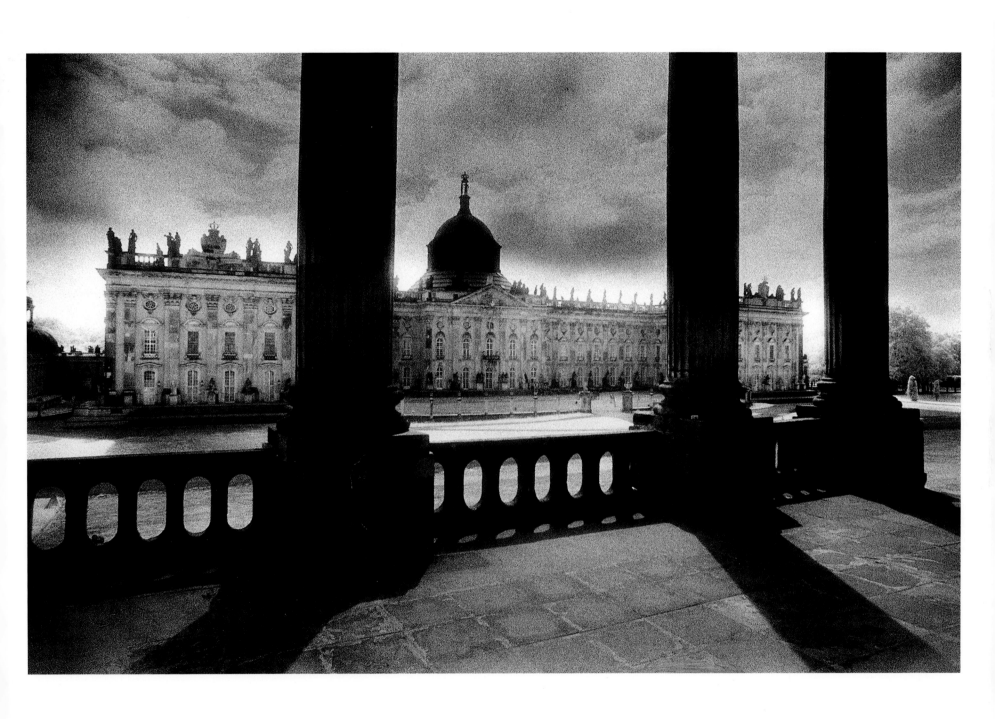

Potsdam

At first light we approached the Neues Palais searching for a caretaker to gain entrance to the grounds, but to no avail. Undaunted, we climbed the tall wire fence that surrounded the many classical statues that had been lined up in front of the Baroque palace. I had found an old postcard in an antique shop in Berlin showing the same scene, but never dared to believe that they might still be there. Now some had name tags or numbers attached and were in the process of being cleaned and restored before being placed back on the roof of the palace.

As I wandered amongst these life-sized sculptures, I felt myself a privileged witness to a unique moment in our history. These are symbols of a grander age that mankind can never erase.

Simon Marsden

Opposite:
Statues waiting to be restored
at the Neues Palais

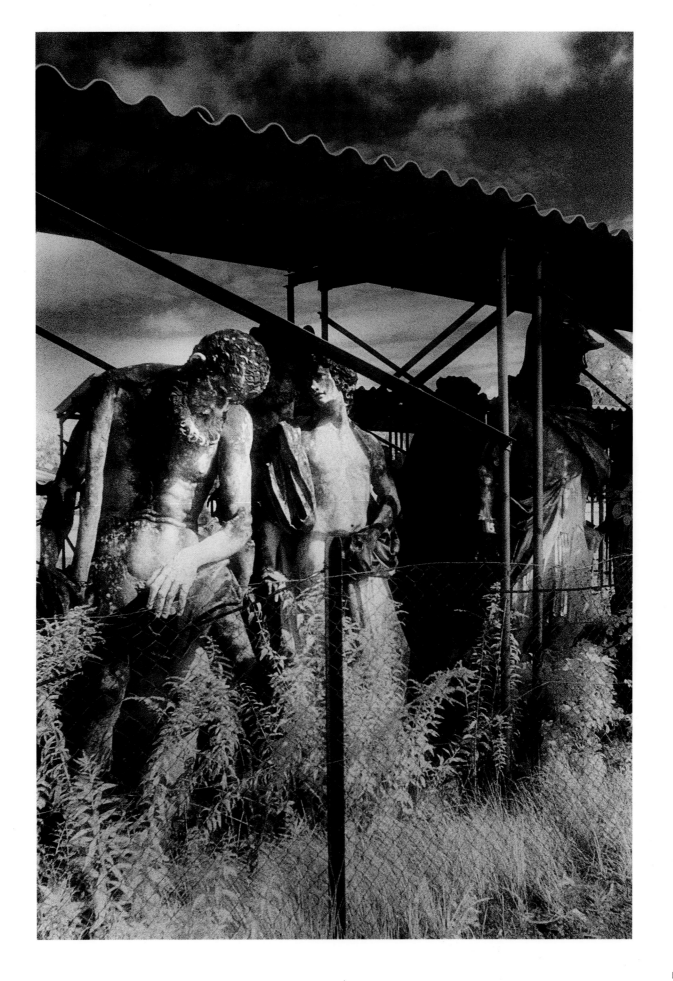

Potsdam

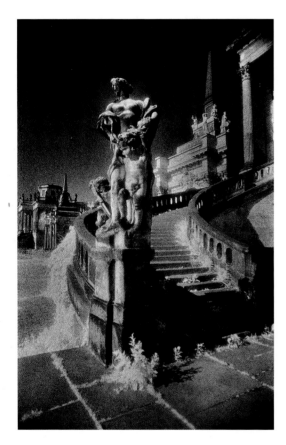

'Fanfaronade' or 'boasting' was Frederick the Great's description of the Neues Palais, where the Communs, the servant quarters and kitchens were housed in magnificently ostentatious façades linked by a curved colonnade. They seemed like little palaces themselves. Now grass and weeds climb the steps up to the pavilions, where only rats and mice take shelter.

Simon Marsden

This great palace was built as a summer residence for members of the Hohenzollern family. Four vast banqueting halls were linked to beautiful royal apartments.

Across the courtyard the extraordinary columned, stepped and sweeping Communs stand like a backdrop to the most spectacular theatre design erected to amuse the grand eyes glancing from the windows of the Neues Palais. It houses not actors waiting to perform, but the servants' halls, kitchens and the domestic staff for the family across the way.

Duncan H. McLaren

Left:
The Communs, built between 1766 and 1769 to the design of Carl von Gontard

Opposite:
Statues outside the Communs

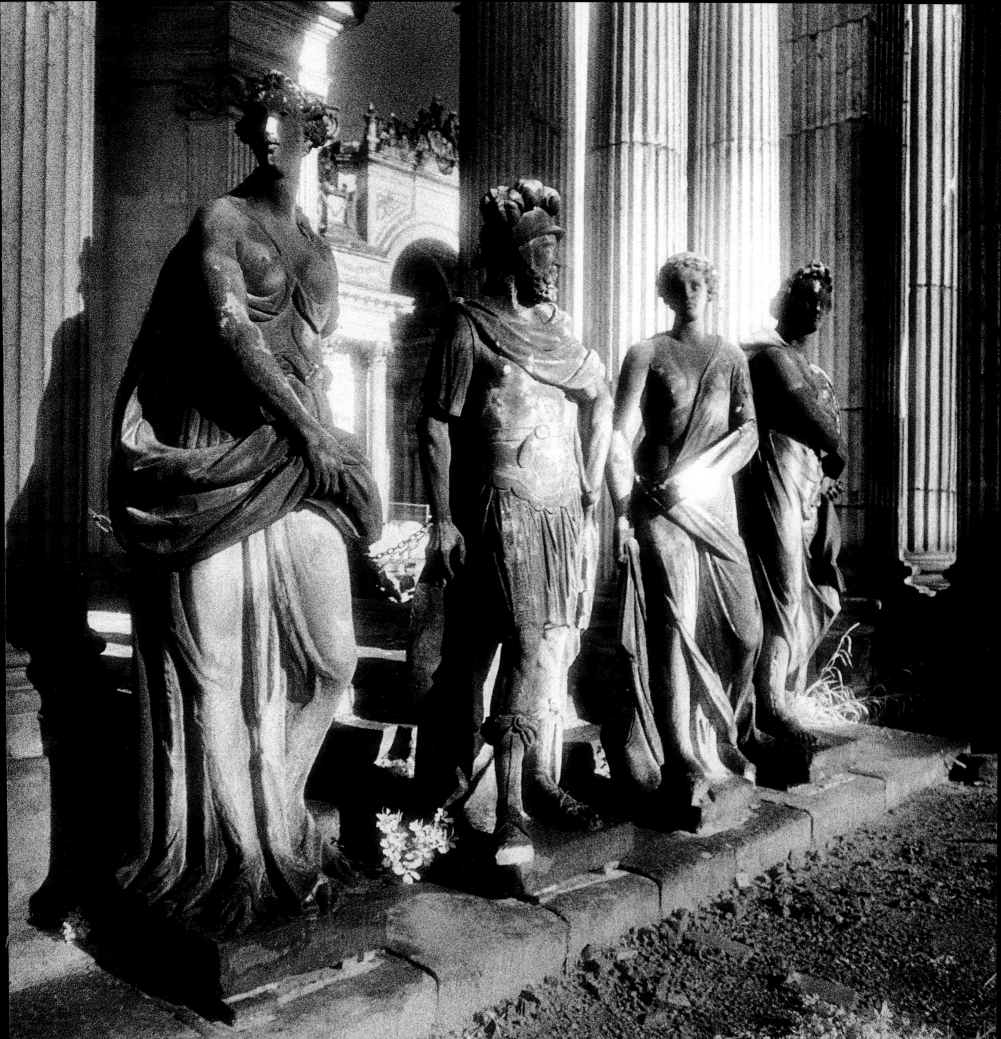

Potsdam
The Prussian Soldier's Tale

In the expulsions of 1732 the Archbishop of Salzburg drove the Protestants out of their homes, but fortunately the King of Prussia was prepared to rescue these lost souls. So it was that the Seideler family was given some land in East Prussia that had been abandoned when the population had been decimated by the Plague.

A house and farm were established in this fertile region and here they lived happily, despite the need to renovate after the buildings were struck by lightning. All this changed suddenly in July 1914 when the village was overrun by the Cossacks. The estate was put to the torch and the old, the women and the children fled to the West. Members of my family serving with the Prussian army were killed liberating their homeland. The family returned to the ruins a year later, however, determined to re-build their lives and their home.

Disaster struck again in October 1944 when Russian troops occupied the village, and the inhabitants had to flee once more. With courage born of despair, German troops counter-attacked, but to no avail. The Seideler ancestral home was occupied by enemy troops and had to be fired on by German 88mm FLAK commanded by the owner's grandson, my father.

Fifty years on the few surviving members of the family are scattered throughout West Germany. East Prussia is lost to us. Our ancestral village is inhabited by strangers, and the house, farm and land lie derelict.

Lt-Col Hans Werner Patzki, 1999

Opposite:
A fountain at Sanssouci Park

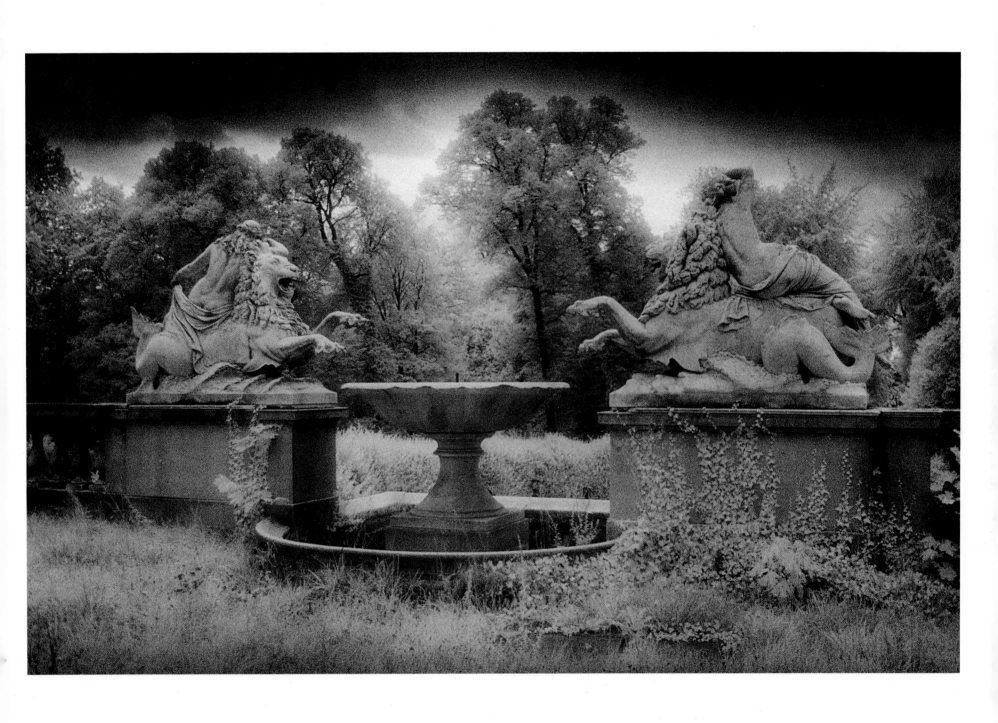

Potsdam

At midnight on 16 August 1991 a small group of German aristocrats carried an ancient sarcophagus across the terrace of Schloss Sanssouci towards a vault where they laid to rest the bones of Frederick the Great, King of Prussia, precisely 205 years after his death.

His final wish had been granted — to be buried in the grounds of the palace he loved, next to his Italian greyhounds, animals whose company he preferred to that of human beings during the last, increasingly eccentric years of his life. When he died, his nephew, Friedrich Wilhelm II, had had his body interred in the Garrison Church in Potsdam itself, next to the father Frederick had hated.

Simon Marsden

Opposite:
A statue at Voltaire Park,
Sanssouci

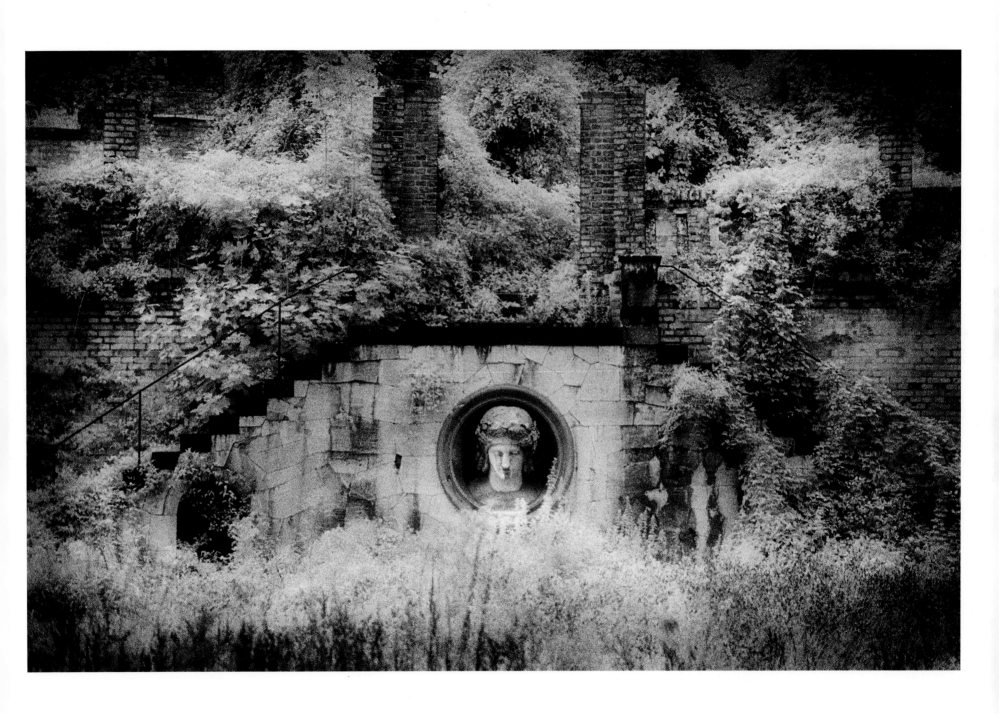

❛ We look forward to a
world founded upon
four essential human
freedoms. The first is
freedom of speech and
expression – everywhere
in the world. The
second is freedom of
every person to worship
God in his own way –
everywhere in the
world. The third is
freedom from want ...
everywhere in the world.
The fourth is freedom
from fear ... anywhere
in the world. **❜**

Franklin D. Roosevelt
1882–1945
Speech, 6 January 1941

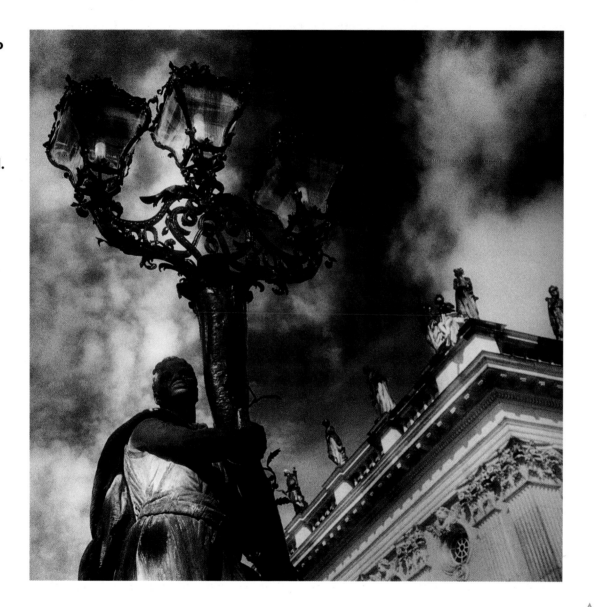

A statue at the Neues Palais.
World attention was focussed
on Potsdam in August 1945
when the victorious allied
powers, represented by
Truman, Stalin and Churchill,
signed the agreement in
the Cecilienhof Palace that
sealed their victory over
Hitler's regime.

A short history
of the expropriation of the estates between 1945 and 1949
and their fate up to now

After the reunification of Germany in 1990 the hope of the former owners of large estates for the return of their old property remained unfulfilled. Indeed it had been stated in the reunification contract between the Federal Republic of Germany and the German Democratic Republic that the expropriations without compensations which had taken place between the time of the foundation of the German Democratic Republic on 9 October 1949 and the reunification were to be annulled. But this principle of restitution did not apply to the period from 1945 to 1949. The government of the Federal Republic of Germany has officially declared that the Soviet Union would only give permission for German reunification on condition that property which was expropriated during their occupational time, 1945–1949, was not to be returned to their former owners. The restitution of these estates, castles and their lands was therefore ruled out in the reunification document. Although the former Soviet President, Mikhail Gorbachov, his then former Foreign Minister Shevardnadze and further high-ranking witnesses – amongst them the American President Bush – have denied that the Soviet Union had made such a demand, it was verified by the highest German Court, the Bundesverfassungsgericht, in two verdicts from 1991 and 1996, that the government of the Federal Republic of Germany had every right to accept such an expressed demand judging by the facts known to them at that time. So the restitution of estates and castles to their former owners remains out of the question.

Today, the land formerly belonging to the large estates is mostly worked on by subsequent companies of the so-called agrarian production companies. The castles and estates, parted from their agrarian surroundings, are mostly exposed to ruin. Intensive troubles taken by the responsible Bundesanstalt for special reunification tasks to sell these houses are only rarely, if ever, successful.

Dr Bernd-Lothar von Hugo
Dr Christof Sieverts
Dohrendorff v. Hugo & Sieverts, lawyers from Braunschweig, Germany

Acknowledgements

Dr Busso von der Dollen

Alexander Fürst zu Sayn-Wittgenstein-Sayn

Herr Wippert

Lt-Col Hans Werner Patzki

Charles Kenyon

General Sir Charles Guthrie

Peter Vickery

Tatiana Gräfin von Waldersee

Konrad Graf von Waldersee

Brigadier Richard Shireff

Heinrich Graf von Spreti

Dr Christof Sieverts

Dr Bernd-Lothar von Hugo

HRH Princess Christa von Preussen

Clementine Sheffield

Angela Sengewald

Klaus-Dieter Witting

Gerhard Brandl

Herr and Frau Rüdiger Wirthmann

Herr and Frau Hofman

Richard Scherer-Hall

Sebastian Cox

The late Joachim von Kruse

Stephan Bloch-Saloz

Alec Herzer

Clare Pemberton

Julia Charles

Andrew Barron

Arianne Burnette

David Young

Cassie Marsden

Without the humour and resourcefulness of our intrepid driver, translator, door opener and bag-carrying friend, we would have been sorely pressed to have completed this book. Our special thanks go to Christof Basil Graf von Spreti.

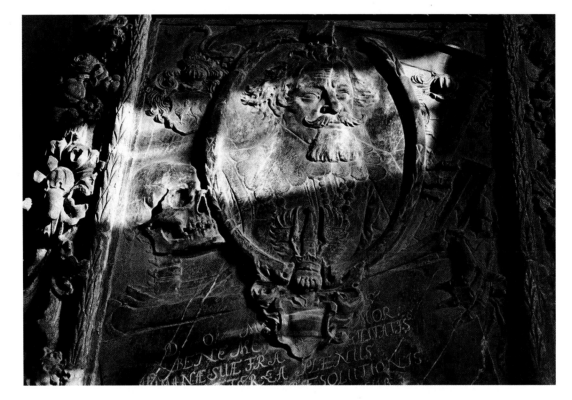

Bibliography

Boyle, Nicholas, *Goethe – The Poet and the Age (Volume I, The Poetry of Desire, 1749–1790)*, Oxford: Oxford University Press, 1991

Buruma, Ian, *Voltaire's Coconuts*, London: Weidenfeld & Nicholson, 1999

Fellman, Walter, *Sachsen*, Cologne: Dumont Buchverlag, 1991

Heaton, John and Judy Groves, *Wittgenstein*, Cambridge: Icon Books Ltd

Humes, James C., *Wit and Wisdom of Winston Churchill*, New York, NY: Harper Collins Publishers Inc., 1994

Leonhard, Wolfgang, *Die Revolution entläßt ihre Kinder*, Cologne: Verlag Kiepenheuer & Witsch, 1990

Menchén, Georg and Wolfgang Leissling, *Burgen, Zwischen Werra und Elbe*, Greifenverlag zu Rudolstadt, 1983

Müller, Hans, *Thüringen*, Cologne: Dumont Buchverlag, 1990

Ohff, Heinz, *The Green Prince: The Adventurous Life of Prince Pückler-Muskau*, Munich, 1991

Quest-Ritson, Charles, *Gardens of Germany*, London: Mitchell Beazley, 1998

von Krockow, Christian Graf, *Die Stunde der Frauen, Bericht aus Pommern 1944 bis 1947*, Munich: Deutscher Taschenbuch Verlag, 1991

Weissbuch ueber die 'Demokratische Bodenreform' in der Sowjetischen Besatzungszone Deutschlands: Dokumente und Berichte, Second Edition, Munich: Joachim von Kruse, Verlag Ernst Voegel, 1988 [First edition published 1955 by Arbeitsgemeinschaft Deutscher Landwirte und Bauern e.V.]

Whaley, John, ed., *Goethe: Selected Poems*, London: Weidenfeld & Nicolson, 1998

A detail from the tomb of Urban, Casper A. von Feilitzch, Salvatorkirche, Kürbitz, Sachsen